HARROGATE
PUBS

INCLUDING
KNARESBOROUGH

PAUL CHRYSTAL

AMBERLEY

Other related books by Paul Chrystal:

Secret Harrogate
Harrogate Through Time
Knaresborough Through Time
Vale of York Through Time
A Children's History of Harrogate & Knaresborough
An A-Z of Knaresborough History (Revised Ed.)
Secret Knaresborough
Changing Scarborough
Secret York
Tea: A Very British Beverage
Coffee: A Drink for the Devil

For a full list please go to www.paulchrystal.com

Front cover illustrations: The glorious Hales Bar in Harrogate with its Victorian gas lighters.

Back cover illustrations: Inside the Blues Café Bar in Harrogate *(left)*; The Commercial Inn in Knaresborough, formerly The Borough Bailiff *(right)*.

First published 2016

Amberley Publishing
The Hill, Stroud
Gloucestershire, GL5 4EP

www.amberley-books.com

Unless otherwise acknowledged all photography is copyright © Paul Chrystal, 2016

The right of Paul Chrystal to be identified as the Author of this work has been asserted in accordance with the Copyrights, Designs and Patents Act 1988.

ISBN 978 1 4456 5318 1 (print)
ISBN 978 1 4456 5319 8 (ebook)

British Library Cataloguing in Publication Data.
A catalogue record for this book is available from the British Library.

Typesetting by Amberley Publishing.
Printed in the UK.

Contents

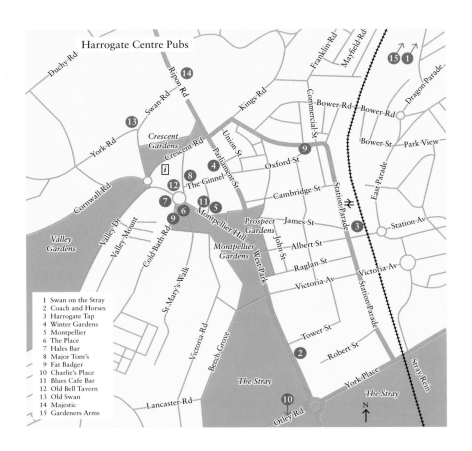

Harrogate Centre Pubs

1 Swan on the Stray
2 Coach and Horses
3 Harrogate Tap
4 Winter Gardens
5 Montpellier
6 The Place
7 Hales Bar
8 Major Tom's
9 Fat Badger
10 Charlie's Place
11 Blues Cafe Bar
12 Old Bell Tavern
13 Old Swan
14 Majestic
15 Gardeners Arms

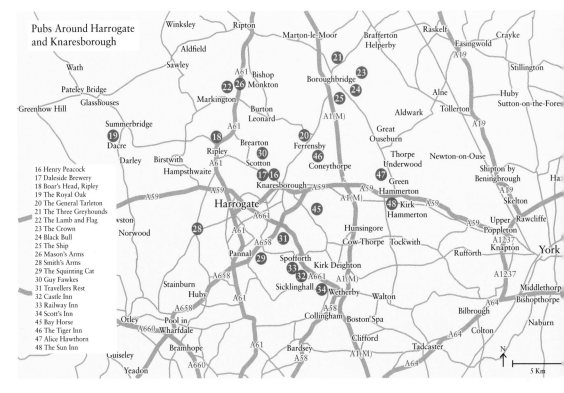

Pubs Around Harrogate and Knaresborough

16 Henry Peacock
17 Daleside Brewery
18 Boar's Head, Ripley
19 The Royal Oak
20 The General Tarleton
21 The Three Greyhounds
22 The Lamb and Flag
23 The Crown
24 Black Bull
25 The Ship
26 Mason's Arms
28 Smith's Arms
29 The Squinting Cat
30 Guy Fawkes
31 Travellers Rest
32 Castle Inn
33 Railway Inn
34 Scott's Inn
45 Bay Horse
46 The Tiger Inn
47 Alice Hawthorn
48 The Sun Inn

Knaresborough Pubs

36 Marquis of Granby
37 Board Inn
38 Castle Vaults
39 World's End
40 Bind Jack's
41 Dropping Well
42 Commercial
43 Dower House
44 Roosters

N

Scale ?

Will someone take me to a pub?
— G. K. Chesterton (1874–1936)

O Yorkshire, Yorkshire: Thy Ale is so strong
That it will kill us all if we stay long:
So they agreed a Journey for to make
Into the South, some Respit there to take.
— George Meriton, *The Praise of Yorkshire Ale*, 1684

There is nothing which has yet been contrived by man, by which so much happiness is produced, as by a good tavern or inn.
— Dr Johnson (1709–84)

When you have lost your inns drown your empty selves for you will have lost the last of England.
— Hilaire Belloc (1870–1953)

Acknowledgements

A book like this is always a joint enterprise between the author and the subject of his book – in this case the landladies and landlords, managers, hosts and hostesses of the fifty or so pubs, bars, inns and beerhouses included. Without their help the book would be deficient in many ways and would be just another arid listing of places to go for a drink.

So, I would like to thank the following, in no particular order, for their help and contributions: Amanda J. Wilkinson, Hales Bar; Eric Lucas and Ian Paradine at Daleside Brewery and Harper Creative Ltd; Lee Belwood at Major Tom's; Helen McGlynn, Literature Festivals Co-ordinator, Harrogate International Festivals for the logo for Harrogate Crime Writing Festival; Vivienne Rivis, Projects Secretary, Burton Leonard History Group; and Tom Fozard, Commercial Manager, Rooster's Brewing Co.

Some of the pubs of Harrogate and Knaresborough included in this book are on what could be a most enjoyable pub crawl. Postcard sponsored by Daleside Brewery, © Bernie Carroll publications.

Introduction

Harrogate Pubs is an accessible and friendly guide to the best of pubs in Harrogate, Knaresborough and the surrounding countryside, extending to Boroughbridge in the north, Spofforth in the south, Dacre Banks in the west and to Nun Monkton in the east. It describes in detail and depicts fifty or so pubs, inns and bars, with additional information on many more – including some which no longer exist or have changed their use. The history and development of these pubs is described with information on origins, significant events and how the pubs got their names or what the names signify. It is, then, an informative and fascinating practical guide for anyone strolling in and around Harrogate and Knaresborough, for hikers in North Yorkshire and those making bike or car journeys in one of England's most picturesque regions.

In 1875 Yorkshire was home to over 10,000 pubs. Now there are significantly fewer with doors closing every week, time being called for the last time all the time. So, if there is a message to take away from this book it is simply put the book down, get up, go out and call in at your local for a pint or two and help preserve and extend this most British of social institutions. Once the pub, your favourite pub, has gone, it's often gone for good.

Yorkshire's first pub was the alehouse in which Samuel Ellis started brewing in AD 953 at Bardsey to the north of Leeds. It has survived to this day under the guise first of the Priest's Inn and then of the Bingley Arms, but the tradition and heritage started by Ellis and the Kirkstall Abbey monks who drank there on the way to St Mary's Abbey in York must be preserved. History cries out from the pub with its monastic tradition, its role as a courthouse, its pillory and its post-Reformation priest hole. Beer was being brewed and drunk here in the days of King Canute (990–1035).

As places go, Harrogate is not typical pub country but Knaresborough is. Harrogate High and Low are two parts of a relatively new town which grew up around the internationally renowned spa; it was the local farmsteads which first slaked the thirst of those affluent people who came to take the waters. These developed into inns, coaching inns and prestigious hotels, complemented and augmented by pubs as we know them today, established to satisfy the needs of an increasingly commercial lower-middle-class clientele. Knaresborough nearby however is a typical market town with its markets in the market square and a plethora of pubs clustered round that square, on the High Street and down the lanes and streets leading into it. The surrounding countryside supported a wealth of pubs to sustain the numerous agricultural workers. All of these pubs, in town and country alike, have a story to tell, and it is these intriguing stories

which fill the pages of this book. In a very significant way, the history of the pub and inn – what J. B. Priestley called 'a haunt of rare souls' – is the history of the region.

People figure large in the book (as does a horse); without them, of course, there would be no pubs, so it is fitting that they take centre stage whether as landlords, customers, coroners, alewives, murderers, mistresses or maids. In the pubs featured there is often someone colourful and interesting not very far away who has tinged or influenced the history of the establishment at one time or another.

In the early days, pubs, particularly pubs out in the country, brewed their own ale in small brewhouses adjacent to the pub. Women did much of the work, certainly before the mid-fourteenth-century Black Death: Madam Bradley of Northallerton and Nanny Driffield of Easingwold are legendary; 'Brewsters' or 'alewives' brewed in the home for both domestic consumption and small-scale commercial sale. These brewsters made a substantial and important contribution to the family income. It was the good ale which drew neighbours into the houses of brewsters and led to the birth of the public house. Some women continued to brew into the seventeenth century, ale-conners routinely tested the quality of ale, and ale with its creamy head literally hummed. Stingo, Knockerdown and Rumtum were famous Yorkshire brews with reputations as far south as London's Marylebone. Hopped ale was introduced from Flanders around 1400 after which time hops were grown in England for beer production (ale usually has a lower hop content than beer).

Apart from these domestic enterprises, hostelries were set up by the roadside catering for travellers. This began with the Romans locating *tabernae* on their extensive road network and continued with merchants going to and from market, drovers, commercial travellers, monks moving from monastery to monastery, pilgrims (as exemplified by Chaucer's *Canterbury Tales*) and other people moving from village to village and from town to town. We have seen how the Bingley Arms was at the forefront of this ecclesiastical activity. The lords of the manor sometime provided refreshing and sustaining beerhouse facilities for the workers in their fields. Ale was an important part of the medieval English diet being as it was affordable and clean compared to water. It is estimated that the average adult drank up to eight pints a day.

But it was not all good news. Brewsters were often scapegoats for the vices associated with the production and consumption of alcohol. In 1540, the city of Chester decreed that no woman between the age of fourteen and forty would be allowed to sell ale, with the aim of limiting the trade to women above or below the age of sexual desirability. Women who brewed and sold ale were notorious for being disobedient to their husbands, sexually deviant, cheating their customers with watered-down ale and charging extortionate prices.

The seventeenth century saw the first big change in the history of pubs when in 1657 the establishment of turnpikes led to a huge increase in the number of horses and coaches criss-crossing the country. Turnpikes demanded coaching inns for board and lodge for drivers and passengers, and stabling for the horses that needed changing every 15 miles or so. The next major development came with the railways 200 years later and the establishment of railway inns at stations; the third was the now-ubiquitous car

and the need to cater for day-trippers, business people and other travellers – often in the very pubs that once served coach and railway travellers.

The first common brewers were the Nesfield family of Scarborough, established in 1691. But it was the end of the eighteenth century that saw the emergence of the common brewery; this was boosted by the Beerhouse Act in 1830, with names from the nineteenth century like Hull Brewery, John Smith's, Sam Smith's, Tetley's, Timothy Taylor's and Theakston's all still very much alive today. The early years of this century have seen the rise of the microbrewery and artisan brewery, two of which feature in this book: Daleside in Starbeck and Roosters in Knaresborough. Some pubs now are tastefully themed, like the Blues Bar, Charlie's Place and Major Tom's in Harrogate; others exude history, notably Hales Bar in Harrogate, the Alice Hawthorn in Nun Monkton and Blind Jack's in Knaresborough; others still can boast fascinating names like the Squinting Cat and the World's End, with their own stories to tell.

Pub signs and the names and the images on them are an intriguing subject all of their own. The Romans started it all with a sign depicting a bunch of vine leaves to denote a *taberna*. As with any other commercial enterprise, pubs used signs or symbols to signify the nature of the business undertaken within. We are all familiar with the barber's pole and the pawnbroker's balls that survive to this day. In York rarer examples exist like the native North American denoting a tobacconists, the statue of Minerva (goddess of wisdom) indicating a bookshop, and the bible outside what was another bookshop. A statue of Napoleon nonchalantly rolling snuff was another sign of a York tobacconist. The reason for all this symbolism was that most people were illiterate until the end of the nineteenth century, so words would have been useless. A sign however, spoke volumes. From 1393 it was obligatory for innkeepers to display a sign; pubs accordingly created names and signs to indicate and differentiate. The sign set it apart from other inns and taverns in the locality. It also advertised what might be found inside, or indeed the political persuasion of the landlord. Coats of arms were a reflection of the custom adopted by noblemen where they displayed their banners outside the inn to show that they might be found within. York's striking gallows sign for Ye Olde Starre Inne stretching over Stonegate is a very rare surviving example of these literally unmissable pub indicators.

Royal Oak was a supporter of Charles II (he hid in one at Boscobel after the battle of Worcester in 1651 before he was king), Punch Bowl was a sign of a Whig, and the Marquis of Granby reflected the philanthropy of said Marquis. Chequers denoted board games while The Board proclaimed that cold meats were on offer inside, the board being what the meats were served on, hence 'board and lodge'.

In 1553 the number of pubs was restricted by law: London was allowed forty, York, eight and Hull, three. It would be hard to find a piece of legislation that was so universally, yet happily, ignored and unenforced. In 1623 there were still 13,000 licensed premises in England. Wellington's Beerhouse Act of 1830 saw licensed premises double in ten years with 25,000 new licenses issued within three months of the enactment. It also galvanised the rise of the common brewery, brewing beer and selling it to outlets rather than for oneself.

The fearless Celia Fiennes called in at Leeds on her trip around the kingdom and gives us a marvellous insight on the price and strength of beer here and a debate as to whether her bar meals should be free or not, in her 1698 *Through England On a Side Saddle in the Time of William and Mary*:

Leeds is a Large town, severall Large streetes, Cleane and well pitch'd and good houses all built of stone. Some have good Gardens and Steps up to their houses and walls before them. This is Esteemed the Wealthyest town of its bigness in the Country its manufacture is y^e woollen Cloth-the Yorkshire Cloth in w^ch they are all Employ'd and are Esteemed very Rich and very proud. They have provision soe plentiful y^t they may Live w^th very Little Expense and get much variety; here if one Calls for a tankard of Ale w^ch is allwayes a groate its the only dear thing all over Yorkshire, their ale is very strong, but for paying this Groat for yo^ur ale you may have a slice of meate Either hott or Cold according to the tyme of day you Call, or Else butter and Cheese Gratis into the bargaine; this was a Generall Custom in most parts of Yorkshire but now they have almost Changed it, and tho' they still retaine the great price for the ale, yet Make strangers pay for their meate, and at some places at great rates, notwithstanding how Cheape they have all their provision. There is still this Custome on a Market day at Leeds, the sign of y^e bush just by the Bridge, any body y^t will goe and Call for one tanchard of ale and a pinte of wine and pay for these only shall be set to a table to Eate w^th 2 or 3 dishes of good meate and a dish of sweetmeates after. Had I known this and y^e Day w^ch was their Market I would have Come then but I happened to Come a day after y^e market, however I did only pay for 3 tankards of ale and w^t I Eate, and my servants was gratis.

A few years later Daniel Defoe, in his *A Tour Through the Whole Island of Great Britain*, agrees – although he is not so obsessed with the bar meals on offer – and inns and beer played an integral role in the lucrative and prodigious wool and textile industry in Leeds:

formerly the cloth market was kept in neither part of the town, but on the very bridge it self; and therefore the refreshment given the clothiers by the inn-keepers, of which I shall speak presently is called the Brigg-shot to this day ... The clothiers come early in the morning with their cloth; and as few clothiers bring more than one piece, the market being so frequent, they go into the inns and publick-houses with it, and there set it down ... by half an hour after eight a clock the market bell rings again; immediately the buyers disappear, the cloth is all sold, or if here and there a piece happens not to be bought, 'tis carried back into the inn, and, in a quarter of an hour, there is not a piece of cloth to be seen in the market.

Pubs, then, were not always just pubs. Many, as we shall see, doubled up as coroner's and magistrates' courts, as markets, morgues and as smugglers' dens; others were also blacksmith's, cobbler's or carpenter's – often the landlord's day job. We know of one in Paull near Hull that served as a lighthouse around 1836. Coaches stopped at coaching inns, then 'railway inns' served rail passengers before and after journeys. More recently, pubs have been part-time libraries, churches and vegetable markets.

Part One
Harrogate

Harrogate's relatively recent emergence as a town of significant size, and as a spa town at that, defines its history and heritage. As late as the 1930s one of the many guides to Harrogate summed up the town as 'the Mecca of the Ailing, the Playground of the Robust' and in that motto lies the essence of the place. The Tewit and St John Wells, the Royal Pump Room, the Royal Baths and The Stray give us the therapeutic, healthy aspect; the Royal Hall, Hotel Majestic and other hotels, Winter Gardens and Harrogate Theatre provide the accommodation, the social and night life. Harrogate, then, does not have the long tradition of inns, alehouses, pubs and gin palaces that other, more industrial, mercantile, working-class and urbanised towns and cities can recall.

Harrogate, unlike nearby Knaresborough, Leeds, Thirsk and Ripon never had a market nor the multitude of pubs that traditionally cluster round the market square drawing in thirsty folk from heaving butter markets, sheep markets, cattle markets, corn markets and the like. There was, though, a Market Hall from 1874. However, despite its short history, its apparent healthiness, its middleclass-ness, its urbanity and its visiting aristocracy, Harrogate has made up for lost time with a rich fund of public houses trading in and around the town today. The first inn catering for the nascent spa trade opened in 1687, but most Harrogate hostelries date from the nineteenth century. Indeed, in 1788 the only entertainment there was in Harrogate was provided by hotels like The Crown, which engaged strolling players to entertain the gentry. In Harrogate you came to take the waters; in Knaresborough you were spoilt for choice with watering holes of a very different kind.

Archaeological evidence confirms that many of the hotels in Harrogate grew out of basic farmhouses. The popularity of the town as a spa rather took it by surprise and it was the innkeepers who rose to the challenge of accommodating the flood of visitors who were initially put up in extended farmsteads, their meals comprising produce from the farms and their piggeries. The Dragon, Granby and Queen – later to become good hotels – were all originally pre-1700 farms. The Queen, or Queen's Head, was the first of these to be built, in 1687. A west wing was added in 1855 with further renovation in 1861 to allow for the provision of board and lodging. The Queen was probably named after Catherine of Braganza, the queen of Charles II who, ironically, declined a jug of foaming beer on her arrival in England, preferring instead a cup of tea from the copious supplies imported as part of her dowry.

The Skipton Quarter Sessions of 1681 reveal early day-license regulation abuse when nine Harrogate 'alehousekeepers' (four of whom were women) 'did illegally, obstinately, and without licence … keep common Alehouses and Tipleing houses and there for the whole time did sell beer & ale'. From this we might assume that there were ale-selling alehouses in profusion, different from the inns and taverns which offered

The Dragon Hotel.

board and lodging, beer and wine – different with different clienteles. Nationally, in 1577, England had one alehouse for every 150 citizens. Before the fuss a Skipton notary, Marmaduke Mathew, Constable of Harrogate for 1637, talks of 'brewsters and innkeepers' being arraigned for serving partridges and the like during Lent.

In Low Harrogate, that increasingly fashionable part of the town down the hill, the earliest opening was The Crown in 1740 near to the Old Sulphur Well. In 1789 Eli Hargrove recorded in his *History of the Castle, Town, and Forest of Knaresborough, with Harrogate and its Medicinal Waters* the explosion in the hospitality trade, 'the water drinkers lodged in the cottages and farmhouses' nearby, describing High Harrogate Dragon, Granby and Queen as 'good inns' and noting that 'several of the inns now receive annually more company than the whole place contained 40 years ago'.

The Crown too, in its name, may have associations with the restoration of the monarchy in 1660 although its origins as an alehouse may reach back as far as Tudor days. Others from the seventeenth century included the Bell, the Promenade and the White Hart, while the eighteenth century saw the opening of The Globe – later known as the Half Moon Inn and The Crescent. The garrisoning of soldiers in Low Harrogate must have galvanised the growth of inns here. The Hoggs, landlords of the Bell, certainly quartered soldiers in 1768 Joseph Hogg was falsely accused of murdering someone who might have been one of them. The *York Courant* tells us that the evidence was based entirely on 'the distempered brain of a woman' who, it is careful to tell readers, was many years ago 'big with bastard child'.

By 1731 Dr Thomas Amory was prescribing a good healthy lifestyle to be adopted at Harrogate comprising fresh air, careful exercise, sensible diet and sleep and – most significantly – wining and dining at the inns along with gaiety, dancing and good humour.

In 1795 Henry Skrine was able to write, 'Three large houses of public resort now flourish [Queen, Granby and Dragon] on the heath of Harrogate [The Stray], and in the high season contain an astonishing concourse of company within their walls. At the Dragon in particular where I have repeatedly made a long sojourn, in pursuit of health from the water, every species of accommodation is provided with the utmost care, and accompanied with the most unvaried attention.'

These three pioneers of hospitality and entertainment in Harrogate were by no means alone – they were regarded as the best and so attracted more 'reviews' than all the others. They were joined by a fourth inn, the well-positioned Salutation Boarding House, between The Dragon and The Granby, which was somewhat lower rent than the others. In 1740 a Richard Lund was advertising the inn as 'at the sign of the Salutation at Harrogate Spa'. There was good stabling, good grass, hay and corn for the horses, while patrons could enjoy 'the best entertainment, civil usage, and a hearty welcome from their humble servant'. The name Salutation may refer to its proximity to a nearby chantry chapel. It was later called the Hope Inn, and then Gascoigne's Hotel and, later still, the County Hotel.

Similarly well placed was the Empress Hotel from before 1640 which later became the Bay Horse. The Bay Horse was occupied by William Westmoreland in 1786, owner of the St John Well, and was big enough to be the venue for a grand inquest of the Royal Forest Court in 1791.

Other inns included the World's End. In 1757 the 'ancient and well accustomed Inn' of Christopher Benson – the Royal Oak – went up for auction. The St George Hotel, opposite the Kursaal, developed slowly but surely from its origins as a small cottage. From 1778

The Crescent Hotel with T. H. Walker's Leamington Well Pump Room to the right.

The Bay Horse as it was before it became The Empress.

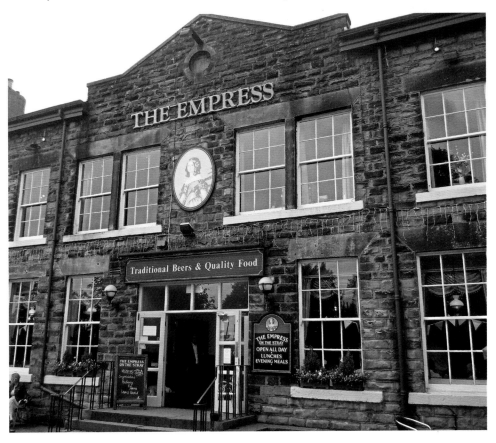

The George today.

it began to offer the services of an inn – the Chequers. On 9 May 1910 Princess Victoria, the King's sister, and the Grand Duchess George of Russia, watched the proclamation of George V as King and Emperor on the steps of the Royal Baths from a window there.

The rear of The George was overlooked by The Swan (later the White Swan) fronting on to the Ripon Road, an inn which was originally called the Smith's Arms and then the Blacksmith's Arms, serving the smithies and forges located on Iron Gate Bridge Road. Jonathan Shutt did up The Swan for the 'Spaw season' in 1782 and rebadged it the White Swan. The New Inn stood at the junction of Cold Bath Road (formerly Robin Hood Lane) and Otley Road from the late eighteenth century. Binn's was close by (later The Lancaster), as were the Robin Hood (later The Wellington) and the White Hart. Briggs' Boarding House on Cold Bath Road became the Victoria Hotel.

The World's End became known in the nineteenth and twentieth centuries as The Grove or Grove House, also on Skipton Road and later the home of Samson Fox. Before that, in 1728, it was promoted as having 25 acres of land (another former farmstead perhaps). The name World's End is usually, but not always, associated with the execution of Charles I; architectural evidence lends credence to the theory that it dates from around 1660 – the accession of Charles II.

The Victoria (left centre) and the White Hart Hotel at the bottom of Cold Bath Road around 1890.

Former names of The Granby include the Sinking Ship (not an example of bad branding but a reference to the defeat of the Spanish Armada) and the Royal Oak – Royal Oak was its name when Blind Jack of Knaresborough played his fiddle there and Harrogate's first theatrical productions were held in the barn. It was renamed The Granby in 1795. Blind Jack, John Metcalf, allegedly eloped with the landlord's daughter on the eve of her wedding to another man in the 1830s. Guests have included Laurence Sterne and Robert, Clive of India. The phrase 'barn-storming' comes from these performances.

Tobias Smollett stayed there in 1766 on his way from Bath to visit his elderly mother in Edinburgh. The *London Evening Post* (Tuesday, 13 May 1766) reports that 'Dr. Smollet, who for some time past has been dangerously ill, is so well recovered, that he is preparing to set out for Harrogate, from whence he proposes to go to Scotland to reside'. Travelling from Beverley via York, John Courtney reached Harrogate on Tuesday 27 May, and took rooms at the 'Marquis Granby's Head'. He tells us of the arrival of 'Dr Smollett [the famous historian] with his sister, nephew with his lady and his sister' and their taking rooms at the same lodgings four days later on the evening of Saturday 31 May. 'The doctor,' he adds, 'is very ill,' the severity of which obliged Smollett to be 'confined to his room' for much of his stay. Despite that, several later diary entries show that within a week the gregarious Courtney felt himself 'pretty well acquainted' with both Smollett and his family.

This is recounted by John Courtney in his *Diary of a Yorkshire Gentleman: John Courtney of Beverley, 1759–1768*. Courtney (1734–1806) was one of Yorkshire's idle rich and the diary is a record of his efforts over nearly ten years to find himself a suitable marriage partner.

Smollett was no fan of Harrogate as this baleful description of his Harrogate spa experience in *The Expedition of Humphrey Clinker* reveals: 'at night I was conducted

into a dark hole on the ground floor, where the tub smoked and stunk like the pit of Acheron'. Acheron is a name for the burning river that runs through Hell, made famous in Virgil's *Aeneid*. After his stay in the town, Smollett describes Harrogate as 'a wild common, bare and bleak, without tree or shrub or the least signs of cultivation'.

First records of The Dragon (named after a Charles II racehorse) go back to 1764 when the owners, the Liddles, won the famous Dunmow Flitch. This entailed married couples going to Dunmow, Essex, and swearing that for a year and a day they had never had a quarrel and never wished themselves not married. The prize was a flitch of bacon. Its origins lie in 1104 at the Augustinian priory of Little Dunmow, founded by Lady Juga Baynard. The then lord of the manor, Reginald Fitzwalter, and his wife masqueraded as common folk and begged blessing of the prior a year and a day after their marriage. The prior was so impressed by their devotion that he gave them a flitch of bacon. On revealing his true identity, Fitzwalter donated land to the priory on the condition a flitch should be awarded to any couple who could demonstrate conjugal harmony and claim they were similarly devoted.

The hotel was also called the Green Dragon and was owned between 1827 and 1830 by Thomas Frith, father of the painter W. P. Frith. Back then it was the five-star hotel of its day, but Grainge reports that 'the tide of popular favour afterwards ebbed away'. In 1870 it became High Harrogate College and was demolished in the 1880s when Mornington Crescent was built. The New Inn on Skipton Road changed its name to The Dragon in the 1900s.

The Royal Hotel opened in 1847 and was extended in 1864. The Prince of Wales Hotel stood nearby at the crossroads formed by the Leeds–Ripon and Knaresborough–Otley roads. Originally it was named after the builder Michael Hattersley in 1820, and was then called The Brunswick until 1866, having been renovated in 1861. Hattersley's was the inn of choice for the Lakes Poets on their visit in 1823; Mary Wordsworth was most taken by its inexpensiveness but by 1825 they had graduated to The Crown on a return visit. The Clarendon Hotel, close to the station, dates from 1847. The Commercial Hotel was built on the site of an earlier hotel, known by the sign of the Obelisk. The Prospect House Hotel, 'the most trim and ornate of all the Harrogate hotels', according to Grainge, stands in Prospect Place on the site of an earlier hotel of the same name. It was rebuilt in 1859 and enlarged in 1870, with its croquet lawns in what is now Prospect Gardens. Parliament Street boasts the Somerset Hotel. The Crescent Hotel stood in Crescent Place near the Royal Pump Room – was formerly known as the Half Moon Inn.

Harrogate and Knaresborough had their fair share of inns which served on the various coaching routes. In 1743 every Monday a Wakefield to Harrogate via Leeds coach terminated at the Queen's Head and turned back to Wakefield. In 1772 there was a coach from Leeds to Harrogate's Crown Inn twice weekly. Gilbertson, landlord of the Queen's Head, started a service from Leeds to Newcastle via Harrogate. Three days a week in 1791 you could get a coach from the Swan to Leeds. Other services served by Harrogate inns included London to Carlisle via Leeds and Catterick Bridge;. The *Liberty* ran from Leeds via Harrogate to the Great North Road to link up with the *Glasgow Mail*. The *Defence* and *High Flyer* both called at Knaresborough and

Boroughbridge en route from Harrogate to Newcastle. Leeds to Harrogate services went via Knaresborough, as did the coaches from Halifax and Leeds to Ripon and Leeds to Richmond. The *True Blue* plied between Knaresborough and Selby to connect with one of the five daily steam packets to Hull. Manchester came on stream three times daily in 1838 from Harrogate.

The area around Devonshire Place was a focal point for coaching routes in High Harrogate, forming the nucleus of roads radiating out to Skipton, Ripon, York and Knaresborough. Accordingly it was a magnet for inns and was the home for The Granby, and for lesser establishments such as the Star Inn, the New Inn, World's End, King's Arms, Devonshire Inn, Black Swan and Salutation. The King's Arms was in the former Green Dragon Theatre from 1782 and two years later was converted into Harrison's Hotel, Coffee House & Tavern.

Apart from the business made from accommodating travellers and stabling and feeding the horses, a number of Harrogate and Knaresborough innkeepers actually ran the coach services and owned coaches. The landlord of the White Hart Inn at Knaresborough, Thomas Peason, had a share in a pair of coaches and drove one of them daily on the Harrogate, Knaresborough, Harewood run. Some of the hotels-inns hired out gigs for daily excursions and ran taxi services locally with horses and mules.

By 1838 High Harrogate could offer fifty-one hotels and lodging houses, but these hotels were now predominantly hotels in the modern sense of the word rather than inns – as indeed were the seventy-nine in Low Harrogate and twenty-one in central Harrogate including the Adelphi in Cold Bath Road. Central Harrogate could boast the Belle Isle Tavern in Chapel Street and The Ebor; the Belle Isle was renamed the Ship Inn before 1839.

The landlords of many of these hotels were of some standing in the community, at least on paper. Thackwray's petition to the Chancellor of the Duchy of Lancaster regarding The Crown was opposed by so-called 'bad disposed persons' like the landlords of The Granby, Binn's, Cross-Roads, Queen's Head, Gascoigne's and White Hart as well as teachers and doctors. It was however, supported by teachers and doctors as well as the landlords of The Dragon, Swan and Crescent. Of the twenty Improvement Commissioners elected in 1841, seven were hotel landlords (Granby, Prospect, Wellington, Crown, Queen, Granby and Dragon) and a further three ran lodging houses.

We have Benjamin Blunderhead Esq. to thank for description of the buzzing Harrogate scene in 1813 from one of his pseudonymous articles in the *Gentleman's Magazine*, entitled 'A Week at Harrogate'. Bored with Bath, he arrived at York which he said reminded him of old Rome, and then proceeded to 'this celebrated watering place'. Getting rooms was a problem The Crown. The Crescent and the White Hart were both full, or said they were; they would not, at any rate, take him in. The real reason of this, he found out later, was because he had no servant man attending him. So he sought lodgings:

I enquir'd of a woman who stood at the door
If thy'd room – and she answer'd with Oh ! To be sure !
Though a deal o' fine folks du to this house repair,
I think we, at prissant, have yan room to spare.

Blunderhead leaves us in no doubt about the exclusiveness of the resort, its magnetic attraction for the wealthy and its snobbery. The age of populism had not yet arrived; it needed the railways to foster that with the day trips and excursions they brought. Nevertheless, he likes the look of The Queen, The Granby and The Dragon, 'three excellent inns on the side of the green', and goes on to list the houses run by 'the famed Mrs Binns', along with The Crown, The Bell, The Crescent, The Swan and The White Hart.

The hotels soon acquired nicknames, indicative of their clientele. The exceedingly posh Granby, popular with the aristocracy, was known as 'The House of Lords'; The Dragon was 'The House of Commons' due to its patronage by the military, gamblers and the racier set. The Crown was known as 'The Hospital' because it was close to the Old Sulphur Well. The Queen was frequented by lower-class tradesmen and merchants and was known as 'The Manchester Warehouse'. It was for the 'great Manchester millocrat, the Sheffield pinmaker, the iron-founder from Black Barnsley … folks who dared not … attempt admission into the Dragon or the Granby'. The Queen, now The Cedar Court, it was reputedly Harrogate's first purpose-built hotel. Blind Jack was resident fiddler here around 1732. Like The Grand, The Queen was requisitioned by the Empire Pilot's Receiving Scheme during the Second World War. It became the headquarters for the regional health authority in 1950 but happily reverted to its intended use in 1990.

In 1819 there were nine inns in High and Low Harrogate usually providing accommodation for the spa visitor. The Granby, Crown, Queen's Head and Swan, for example, developed into hotels, but the pub and inn continued to proliferate to satisfy the social needs of the less affluent crowds taking the waters. The 200-year-old Hales Bar, The County on The Stray, opened in 1830 and the North Eastern opposite the station are examples.

Blind Jack had connexions with Harrogate as well as with Knaresborough. At the age of fifteen, he was appointed fiddler at the Queen's Head in High Harrogate. Later, he earned money as a guide (working mainly at night), eloped with Dolly Benson, daughter of the landlord of the Royal Oak (later The Granby), and in 1745 marched as a musician to Scotland, leading Captain Thornton's 'Yorkshire Blues' to fight Bonnie Prince Charlie's rebels.

John Feltham's 1804 *Guide to All the Watering and Sea-Bathing Guide* tells us how Harrogate society worked and noted the practice of men and women remaining in the same room after dinner whereby 'the ladies, by this custom, have an opportunity of witnessing the behaviour of gentlemen; and the latter of determining how well qualified the former may be for presiding over a family.' On entertainment generally: 'Deep play, of any kind, is seldom practised at Harrowgate; the person who could renounce female society, which is here to be had without difficulty, for a pack of cards, or a faro bank, would be generally avoided. Another advantage of mixing freely with the ladies, is the sobriety it ensures; to which the waters, indeed, contribute not a little'.

Thorpe's 1891 Directory informs us that around the end of the nineteenth century and the start of the twentieth the situation socially was as follows: the hotels, hydros and boarding houses of Harrogate tended to reflect the dominant temperament of the guests. There is always abundance of social pleasure in Harrogate because of the general superiority of its visitors … hotels fix their dinner hours somewhat late to enable their

guests conveniently to avail themselves of the amusements provided at the Theatre, Concert. Rooms, &c. The Theatre hour of commencement is, on this account, arranged for eight o'clock … There are also a number of smaller establishments in the town, where visitors will find their requirements carefully studied. The "Imperial" in Royal Parade, "The Spa" in Cornwall Road, "The Connaught" in Cold Bath Road, and "The Cairn" in Ripon Road. The last named is the newest addition to the list, and already shows signs of business energy. The hydros, as well as hotels, are popular with the mercantile people who seek a few days rest at the end of the week in Harrogate, from Saturday to Monday or Tuesday. Every year there is a large and growing influx of this element'.

As anywhere, Harrogate inns were not just confined to the business of providing drink, food, accommodation and stabling, crucial as such services were. In Harrogate we have seen how the Bay Horse held an important court: to this we can add the 1784 meeting of the Harrogate churchwardens at The Salutation and in 1780 Thomas Linforth's Globe was the venue of the town meeting. The Commercial Inn was the setting for a murder inquest in 1848. Two daughters, Sarah and Abigail Stubbs, had thrown their father down the stairs to his death – they were put out and unhappy about the money they got from their mother, Ann Stubbs, for the help they had given her with the washing she had taken in at their home in Tower Street. The girls were later acquitted.

So, while the emphasis was on catering for well-heeled visitors of the comfortable classes in pursuit of physical and mental healing, Harrogate inns and pubs were aplenty, and they always were, if only in the background, serving the people who serviced the hotels, guest houses, hospitals, gardens and spas plus their visitors.

THE SWAN ON THE STRAY

> 17 Devonshire Place, Harrogate HG1 4AA
> 01423 524 587
> http://www.markettowntaverns.co.uk/swan-on-the-stray.
> asp?Tavern=Swan-on-the-Stray&Section=Main

The Swan on the Stray used to be called the Black Swan – hence the sign. It was extensively refurbished before its reopening in February 2010. There has been a Black Swan on this site in High Harrogate since at least the latter part of the eighteenth century. In 1815, there is a record revealing that 'the workhouse committee refreshed itself liberally at the Black Swan, receiving a bill from Landlord Joseph Waite for £5 6s.10d'. Alright for some.

Devonshire Place was developed towards the end of the eighteenth century and was a stop on a major coaching run. The Black Swan building underwent its first big redevelopment in 1895: a Victorian frontage was erected and it is probable that the height of the building was increased at this time. The cellars reveal evidence of a much earlier building from the eighteenth century including vaulted ceilings.

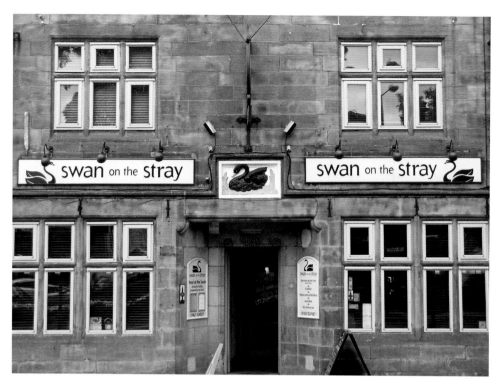

The Swan on The Stray with its impressive black swan sign in relief over the door.

THE COACH & HORSES

16 West Park, Harrogate HG1 1BJ
01423 561 802
info@thecoachandhorses.net
http://www.thecoachandhorses.net/about/

The Coach & Horses opened around 1827 at the junction of Tower Street and West Park, and was one of eight public houses in the area. These included the Brunswick Hotel at the southern end of West Park, now private residences called Prince of Wales Mansions; at the northern end was Mr Muckle's Vaults. Tower Street was home to the Albert Hotel and the Coach Maker's Arms, opposite what is now the Tap & Spile, which was called the Belford. Next door to the Coach & Horses was the Golden Lion, and then The Obelisk, which was rebuilt in 1838 as The Commercial, before becoming the West Park Hotel in 1899. Between The Commercial, doing a brisk trade as a coaching inn, and The Brunswick was The Clarendon, enlarged and adapted in 1847. The Lancaster House Hotel was described in 1830 as being 'fitted up in a most elegant manner'.

By the end of the nineteenth century the Coach & Horses had expanded so much that there were no fewer than seven doors at the front of the building. In 1891 when the pub was put up for sale it had a smoking room with an entrance on West Park, a front vaults

with separate corner entrance and a back vaults with an entrance from Tower Street. The Coach failed to achieve the asking price of £9,000 so it was mortgaged to John Smith's Brewery. When this mortgage was foreclosed in 1912 the brewery took over.

In 2013 John Nelson, the landlord, was doing his best to halt a spate of car crashes outside his pub but ended up in court for his efforts. He moved an arrow pointing to two nearby car parks and for weeks afterwards there were no more incidents. Council officials moved the sign back and within days there was another collision on the road. John moved the sign again with the same success, but again the council undid his good work and installed a camera which caught Mr Nelson red-handed. The police charged him with causing £400 worth of damage.

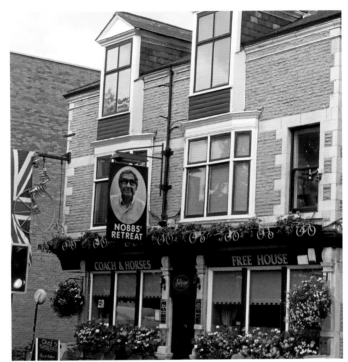

The Coach & Horses paying homage to local hero David Nobbs, writer of the celebrated TV series *The Fall and Rise of Reginald Perrin* (1976–79). Nobbs died in August 2015 aged eighty.

HARROGATE TAP

Station Parade, Harrogate Station, Harrogate HG1 1TE
01423 501 644
enquiries@harrogatetap.co.uk
http://harrogatetap.co.uk/

The Tap is on the only part of the old 1862 Harrogate Station which remains; it was formerly the refreshments room and station bar and was the first building in Harrogate to be built of brick. The renovation work included restoring the original

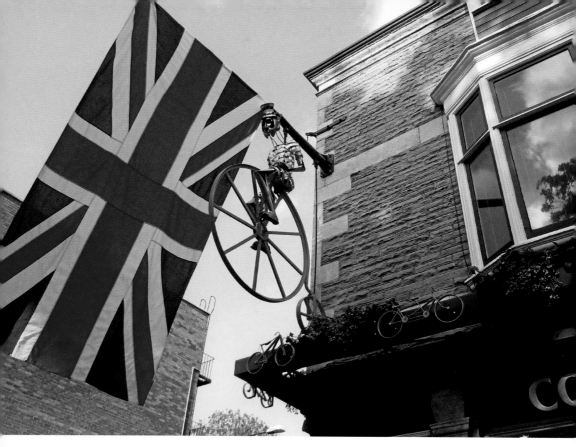

The Coach & Horses marking the route of the 2014 Tour de France with a bike-riding skeleton.

frontage, demolishing a grotesque '60s lean-to, a new roof and interior restoration of the original decorative ceilings that all took around six months.

Before the station was built visitors arriving at Harrogate by train had to get off at either the Brunswick station at the junction of Otley and Leeds roads, or at Starbeck station, both of which opened in 1848 – not very convenient for visitors travelling to Harrogate for the spa season, or for retailers and shoppers. The railway company bought 5 acres of land from the estate of the former Dragon Hotel, owned by the wealthy Joshua Bower. Controversially, part of the south Stray was cut through, compensated by adding to the Stray land released by the closure of Brunswick station.

The station was opened for traffic by the North Eastern Railway on 1 August 1862, had two platforms and was built as part of the NER's plans to improve services to the town.

In November 1866 a storm sent a chimney stack through the roof of the station causing extensive damage. In 1873 a footbridge was built and in December 1868 the booking office was raided when thieves drilled through the ticket office window covering with a bit and brace, and stole cash. In 1892 there was an attempt here on the life of the famous actor Harry Fischer by Violet Gordon. She missed with her shot and was duly arrested.

The 21 June 1902 edition of the *Harrogate Advertiser* reports an assault on Harrogate's first station master, Charles Matthews: 'In 1864, Mr Charles Matthews, the first Station Master, whilst on duty, was brutally assaulted by a gang of militia men, and for six months lay at death's door … It appears that on Saunday nights the station used to be place of resort for young folk, and that passengers by train were much annoyed by the general behaviour of the militia men. In view of the complaints made, Mr Matthews decided to exclude the militia men from the platform. This the men resented, knocked the porter in charge down, rushed on the platform, and, attacking the station master with buckled belts, left him unconscious on the ground. As a result, however, terms of imprisonment varying from, six months to five years followed.'

The Harrogate Tap – a pleasant place to wait for a train.

WETHERSPOONS WINTER GARDENS

4 Royal Baths, Harrogate HG1 2RR
01423 877 010
http://www.jdwetherspoon.co.uk/home/pubs/
the-winter-gardens

A splendid setting in the former Winter Gardens. Concerts were a popular attraction here with bands like Cecil Moon's Palm Court Trio making regular appearances to

packed houses. In the 1930s the Municipal Orchestra played every morning throughout the year, with free admission for the patients of the baths. The Gardens opened in 1897 and were demolished in 1936 when the Lounge Hall and Fountain Court were built to replace them. All that remains are the original stone entrance foyer and staircase. The days of such top-class entertainment by the likes of Britten, Segovia, du Pré and Menuhin are over.

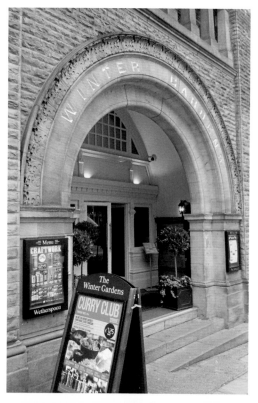

Wetherspoons Winter Gardens elegantly preserved, inside and out.

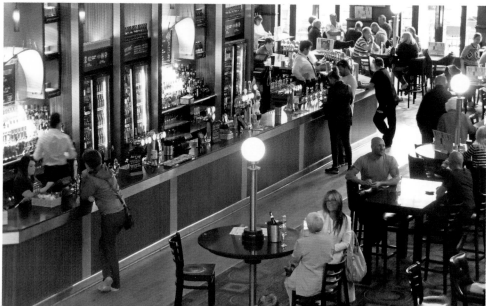

THE MONTPELLIER

14 Montpellier Parade, Harrogate HG1 2TG
01423 817 248

The Montpellier Quarter
The stylish and cosmopolitan Montpellier Quarter is home to around eighty exclusive shops, pavement cafés, bars, pubs and restaurants; the Montpellier Quarter epitomises the best of Harrogate. The many antique shops and art galleries rub shoulders with Farrah's famous toffee and food emporium, Bettys Tea Rooms, Hales exuding Victoriana, the vibrant Blues Bar and the Montpellier pub.

Map of the fashionable Montpellier Quarter, location of some of the finest pubs and hotels.

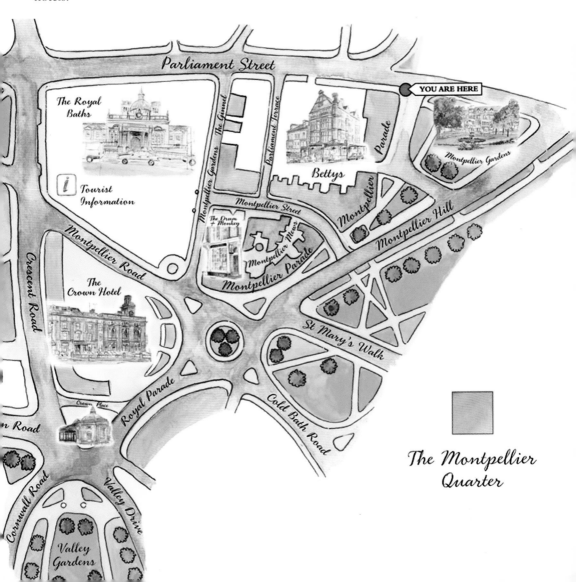

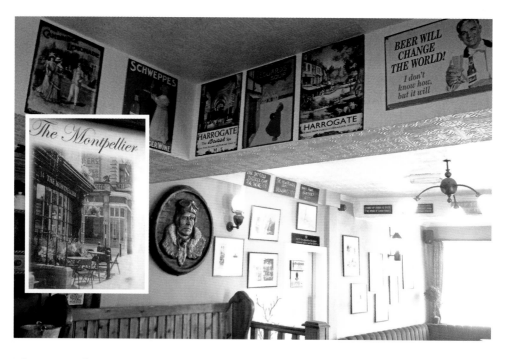

The Montpellier today and (*inset*) yesteryear with its tastefully decorated interior.

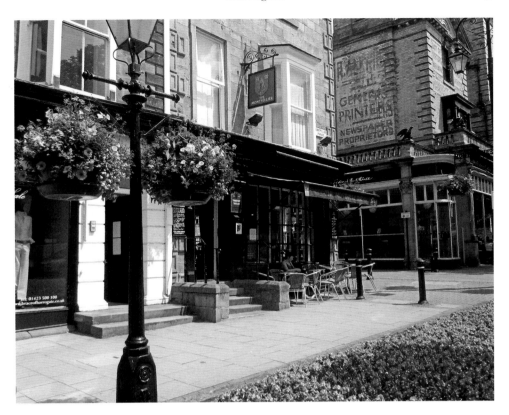

The Montpellier exterior today.

THE PLACE

The Crown Hotel, Crown Place, Harrogate, HG1 2RZ
01423 567 755
http://www.crownhotelharrogate.com/The-Place.aspx

Built originally in 1740 by Joseph Thackwray, great-uncle of the owner of Montpellier Square and Gardens, The Crown was renovated in 1847 and again in 1870. Thackwray was given permission to buy The Crown by King George III, in 1778. In 1784, the head waiter, William Thackwray, was making so much money that he was able to buy the Queen Hotel.

Thackwray was no fool: in 1822 he discovered a number of new wells, one of which was a sulphur well called the Crown Well, and another he channelled into the back yard of The Crown. This led to an Act of Parliament giving Harrogate powers to protect their mineral waters against such piracy.

After honeymooning at the Croft Spa Hotel near Darlington, Lord Byron stayed in 1806 with 'a string of horses, dogs and mistresses'. If the hotel was dog friendly before Byron checked in then it may have reviewed its canine policy when he checked out. Boatswain (a Newfoundland) and Nelson (a bulldog) were their names and, according to Grainge, they

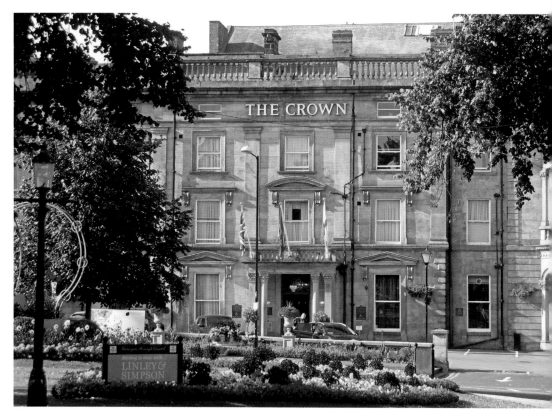

The impressive Crown today.

'had a mortal antipathy to each other, and whenever they met a battle was the consequence'. According to Byron's friend and biographer Thomas Moore, in the summer of 1806, when he and Byron were vacationing together at Harrowgate, 'The bulldog Nelson always wore a muzzle, and was occasionally sent for into our private room, when the muzzle was taken off much to my annoyance, and he and his master amused themselves with throwing the room into disorder. There was always a jealous feud between this Nelson and Boatswain, and whenever the latter came into the room while the former was there, they instantly seized each other, and then Byron, myself, Frank, and all the waiters that could be found, were vigorously engaged in parting them; which was, in general, only effected by thrusting poker and tongs into the mouth of each.' Grainge continues, 'One day Nelson escaped out of the room without his muzzle, and going into the stable yard, fastened on the throat of a horse, from which he could not be disengaged. The stable boys ran in alarm to find Frank, the valet, who, taking one of his lordship's pistols, shot Nelson through the head, to the great regret of the poet.'

While here Byron wrote 'To a Beautiful Quaker', inspired it seems when he happened to notice a pretty Quaker girl nearby. Elgar visited in 1912. In the Second World War the Government requisitioned The Crown for the Air Ministry – who finally vacated in 1959 – and the Beatles apparently stayed here in 1963.

HALES BAR

1–3 Crescent Road, Harrogate HG1 2RS
01423 725 570
awhgt@yahoo.co.uk / http://www.halesbar.co.uk/

One of the most historic and oldest pubs in Harrogate, Hales Bar is the town's only traditionally gas-lit bar. Its origins hail as far back as the earliest days of the town's rise as a leading spa resort and it was one of the first inns to cater for spa visitors after sulphur wells were first established in the mid-seventeenth century. Sulphur springs still bubble beneath the cellar and their unique smell occasionally percolates up to the bar area.

There are records from the seventeenth century to inns close to the Old Sulphur Well, mostly from the Pannal Constable, who noted that he went to 'sulfer wells to cease quarrels'; probably it was The Bell, Promenade and White Hart inns which were implicated in this antisocial disorder.

The Bell and Promenade inns were in existence at the time of the 1778 Award, which divided up the Royal Forest. Both were tenanted by Joseph Hogg, and the map of the

The pub that exudes Victoriana, and a good line in toilet humour.

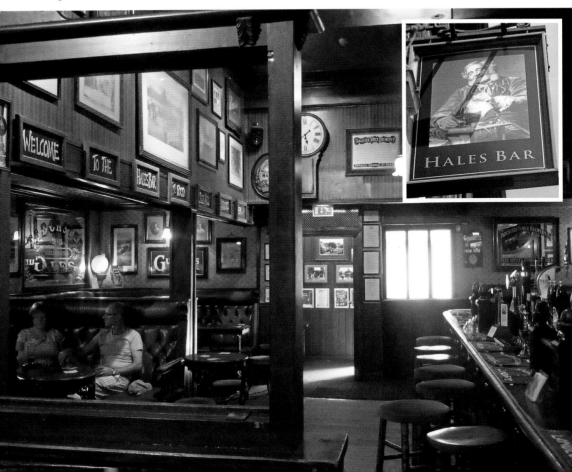

 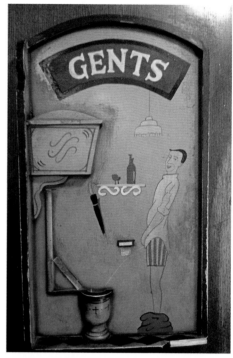

The Vault Bar.

Gas lamps and local history books in the wonderful Hales.

Award depicts a small building on the site of the Promenade Inn. The name Promenade appears in 1822, associated with the neighbouring Promenade Room, now the Mercer Art Gallery, built in 1805–6. Hales Bar took over the licence of The Promenade when the latter closed in 1840 and was bought by the brewer and developer Thomas Humble Walker for £1,220. Mr Walker extended the old Promenade Inn during the 1840s: the older building was converted into a house, the newer part became an inn which initially took the name of the new landlord, Hodgson. In around 1882, Hodgson was replaced by William Hale.

The old Promenade is often called a coaching inn but there are no records of any coaches stopping there. The confusion may arise from the inn's proximity to the Promenade coaching office behind the Bell Inn, from where the coaching companies operated.

The main saloon bar preserves the Victorian atmosphere well, with mirrors and other interesting features and fittings from Victorian days, including traditional gas lighting and cigar lighters. Tobias Smollett most certainly drank here when in May 1766 he visited Harrogate, the setting for part of his novel *The Expedition of Humphry Clinker*. Hales was a favourite too of Sir John Barbirolli when the Hallé Orchestra was in town; some interior scenes for *Chariots of Fire* were set here. Refurbishment in 2013 exposed some original beams and stonework that have been sensibly left open to view.

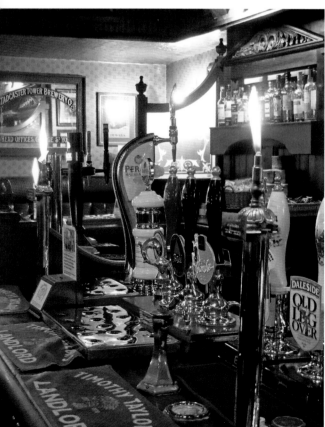

Above: Hales in 1980.

Left: Gas lamps and bar-top cigar lighters.

MAJOR TOM'S SOCIAL

The Ginnel, Harrogate HG1 2RB
01423 566 984
info@majortomssocial.co.uk

A café bar housed upstairs in a former antiques emporium. 'A youth club for grown-ups' is how Major Tom's Social accurately describes itself. Situated on the first floor, over Space, Harrogate Major Tom's Social is a big room with old sofas around the sides and decorated with evocative memorabilia such as vinyl records and posters of classic films. Major Tom's opened in February 2014, it seems to always been a place of entertainment in one form or another: it was dancehall in the early 1920s, a place for rest and recuperation by the troops in the 1940s and a nightclub in the '70s. It may also have been a masonic lodge at some point. Before it was refurbished as Major Tom's it served time as an antique centre with lots of individual traders under one roof. The upstairs was split into around ten different shops and it had a small café. Now there is a vintage shop downstairs and a record shop upstairs with the bar/café.

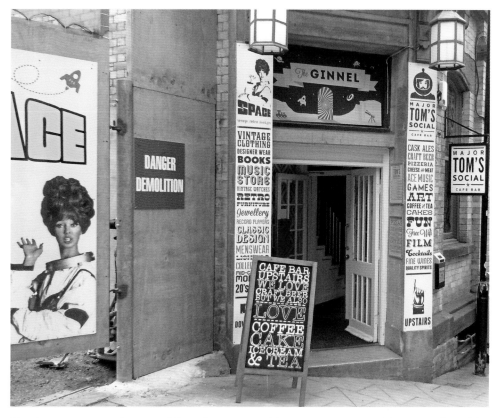

If a bar space can be an oddity then Major Tom's is a space oddity: comfortable, congenial with fantastic fittings and décor.

THE FAT BADGER

White Hart Hotel, Coldbath Road, Harrogate HG2 0NF
01423 505 681
contactus@thefatbadgerharrogate.com
http://www.thefatbadgerharrogate.com/about/bar.htm

'Attached to the slick White Hart Hotel, the Badger has been given a rather OTT makeover. With its taxidermy, oil paintings, Chesterfield sofas, faux-flickering gas lamps and handsome dark-wood fixtures, it looks how big old Victorian pubs might had Laurence Llewelyn-Bowen been alive at the time.' So said *The Guardian* about the Fat Badger. Built in 1846, the neoclassical White Hart is, in Pevsner's estimation, 'easily the best building in Harrogate ... with nothing gaudy or showy about it'. The Jarrow Crusaders paused here on The Stray at the front of the hotel in 1936 en route to London.

The White Hart Hotel is unusual in that its name has not changed in its 250-year history. The name derives from the days when large tracts of England were covered with forests, owned by the king and used for the royal hunts. There may also be a connection with visitors to the White Well which seems to have been a long row of two-storeyed structures, built of coarse sandstone and covered with whitewash. Later in the eighteenth century the founder of Methodism, John Wesley, stayed at the White Hart.

The *York Courant* for 20 August 1765 contains the earliest known reference to the White Hart, which announces that 'Stray'd or conveyed on the 14th August from Thomas Wray's at the White Hart in Low Harrogate, a dappled grey mare ... whoever shall give notice of the same ... 15 shillings reward and reasonable charges'. In 1778 the development of 200 acres of 'Stray' south of the White Hart's façade, greatly benefited the inn, providing it with an open and expansive vista. The White Hart was where the Half Moon Inn was auctioned in 1781, and became an important stop on the coaching routes, notably the Harrogate–York *Diligence*. In 1773 the White Hart became implicated in the early growth of Methodism locally when Mary Bosanquet preached before a huge crowd in the ballroom.

In 1929 Sir Arnold Bax was one of many celebrated names to stay at the White Hart during the All British music festival. Ten years later the White Hart was occupied by the air ministry and the ministry of works; when the war ended the building was acquired by the county council of the West Riding of Yorkshire. The authority toyed with the idea of converting the hotel into an art school, but when Harrogate was earmarked as a centre of excellence for rheumatism research, the White Hart, along with the neighbouring Crown Hotel, was on the verge of being purchased by the state as an annexe hospital for the Royal Baths. The plan floundered but in 1949 the White Hart passed to the Leeds Regional Hospital board and became the National Health Service's only dedicated conference venue until it was acquired by the University of York in 1988.

Badgers everywhere here – no sign of a cull.

CHARLIE'S PLACE PUB & BAR

> 62 Otley Road, Harrogate HG2 0DP
> 01423 551 869
> http://www.charliesplace.co.uk/contact-us.html

Charlie is Charlie Tinker whose passion for 1950s and '60s rock music and Harley Davidsons is reflected in his idiosyncratic place. Live bands are a regular feature. Also known as No 62, formerly Salt Box.

THE BLUES CAFÉ BAR

> 4 Montpellier Parade, HG1 2TJ
> 01423 566 881
> http://www.bluesbar.co.uk/archive.html

For over twenty years now this wonderful bar, modelled on an Amsterdam café bar, has provided a refreshing visual – and audible – alternative to the genteel establishments which characterise Montpellier. Top-quality, free live music every night of the week is its hallmark, as well as, of course, the good beer. There are residential slots for local musicians, regular jam sessions and appearances from bands as far afield as California, Africa and Canada.

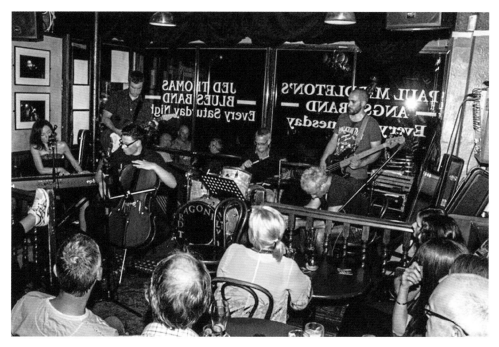

One of the best bars in Yorkshire for atmosphere and music.

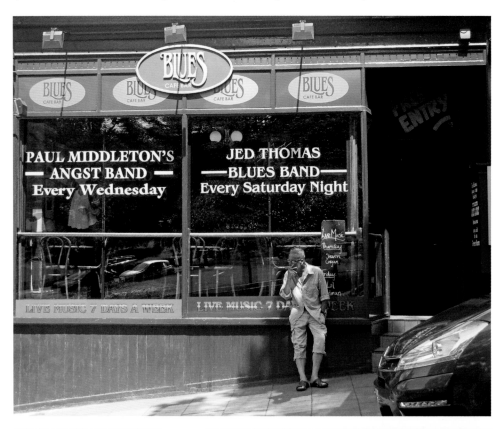

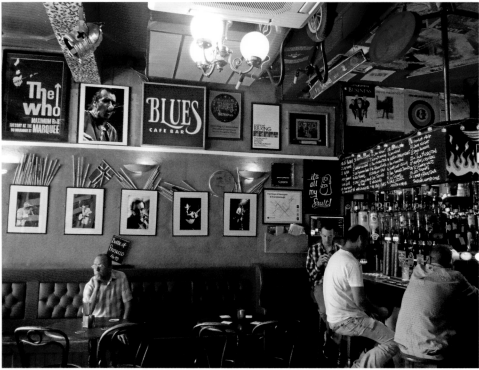

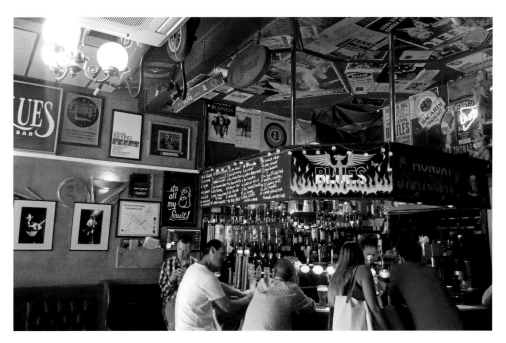

OLD BELL TAVERN

6 Royal Parade, Harrogate HG1 2SZ
01423 507 930
http://www.markettowntaverns.co.uk

In 1786 the tenants of the original Bell reputedly 'provided a stock of the best wines and other liquors, and furnished the house in a manner commodious for the reception of the genteelest families'. The tavern's name refers to the fact that until 1815 an earlier inn, The Bell, occupied the site. The original Bell Tavern was one of the early seventeenth-century alehouses which served visitors to Harrogate's world-famous Old Sulphur Well that lies beneath the dome of the Pump Room museum opposite. It was sometimes called the Blue Bell because of the colour of its sign. The inn was also a stage in the York–Harrogate coaching journey; the 'machine' had its York terminus at the Black Swan in Peasholme Green, there arriving 'in time for dinner'. The Bell tavern closed in November 1815, after which the property was a private residence until 1846 when the site was cleared for the building of the Royal Parade; the original Bell's cellars were incorporated into the new building. A set of historic drawings showing the original Bell Inn are on display in the Old Bell bar lobby area.

In November 2001 the ground floor of No. 7 Royal Parade was incorporated into the tavern. This was originally the world-famous Farrah's Harrogate Toffee shop: the room has been restored to its former glory with the centrepiece comprising the original Farrah shop display unit – a veritable museum of Farrah memorabilia. According to a newspaper clipping on the wall, President Bill Clinton visited the pub during a trip to Britain. He downed a Diet Pepsi.

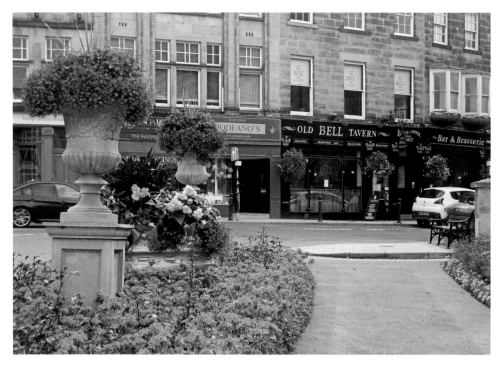

The Tavern today.

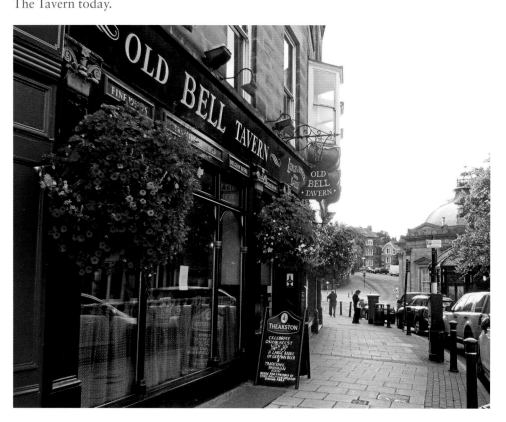

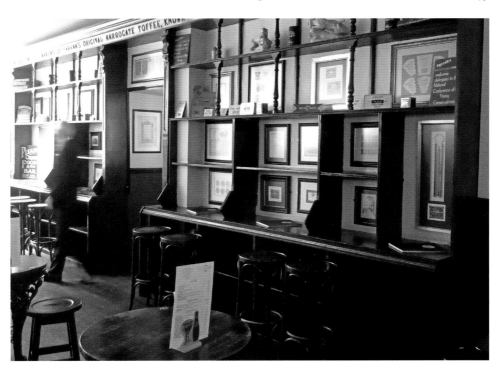

The fascinating Farrah's paraphernalia.

OLD SWAN HOTEL BAR AND LOUNGE

Swan Road, Harrogate HG1 2SR
01423 500055
http://www.classiclodges.co.uk/our-hotels/the-old-swan/

The Swan Inn was built around 1700 as the Old Swan and was run by Jonathan Shutt who began receiving visitors at 'the Sign of the Swan'. In 1820 it was rebuilt and named the Harrogate Hydropathic, reverting first to the Swan Hydropathic and then to the Old Swan Hotel in 1953. The Hydropathic had 200 bedrooms, each with a coal fire, and was the first in Harrogate to be lit by electricity. The first resident physician (and one of the directors) was a Dr Richard Veale who came from Cornwall to Harrogate to develop hydropathic cures; it was originally modelled on Smedley's Hydro at Matlock. To make it fully compliant with its health objectives, the Hydro sacrificed its alcohol licence, banned smoking and made morning prayers compulsory. Visitors must have endured something of a monastic stay.

In 1926 Agatha Christie took refuge here (when it was called the Harrogate Hydro). It was a bad year for Mrs Christie: her mother had recently died and she discovered her husband's affair. Christie had left her home in Sunningdale, Berkshire at around 9.45 p.m.

Shooting a scene for *Emmerdale* in the cocktail bar in September 2015.

on 3 December leaving her car perched perilously on the edge of a chalk pit called Silent Pool at Newland's Corner in Surrey. She then took a train to Harrogate after seeing a railway poster advertising the resort. At the time, the fact that she may have been suffering from depression was discarded and popular opinion, ever cynical, had it that Christie preferred to believe that she was staging a publicity stunt to boost her book sales. Christie checked in under the name of Theresa Neele – bizarrely, the name of her husband's mistress – and set about enjoying her stay. So began the hotel's association with murder, mystery and suspense. Meanwhile, a nationwide search was underway – the first in the country to involve aeroplanes and the biggest then in British history. After ten days, Bob Tappin, a banjo player at the hotel, recognised Mrs Christie, alerted the police and so drew a close to this very real-life mystery.

The striking swan sign was made to commemorate the coronation of Queen Elizabeth II in 1953. The Beatles apparently stayed here during their 1963 visit for the concert at the Royal Hall; General Manager Geoffrey Wright was appalled at the idea of them darkening his doors but took their money anyway. The group had tried to get into the Hotel St George, but were turned away because they looked too scruffy.

The Old Swan Hotel hosted the International Toy Fair in the 1960s, thus paving the way for Harrogate to become a leading conference and fair venue. In 1979 *Agatha* was released starring Vanessa Redgrave, Dustin Hoffman and Timothy Dalton; some of it was shot in The Swan and in the vicinity of the hotel. Theakston's Old Peculier Crime Novel of the Year Award is a prestigious crime-fiction award, sponsored by Theakston's Old Peculier and awarded annually at the Harrogate Crime Writing Festival. The Old Swan hosts the event.

Crime lives on at the Old Swan.

REGENCY BAR, HOTEL MAJESTIC

Ripon Road, Harrogate, North Yorkshire, HG1 2HU
01423 700 300
http://www.thehotelcollection.co.uk/hotels/majestic-
hotel-harrogate/contact-us/

The Majestic's origins lie in a squabble between a local businessman, Sir Blundell
Maple, and the Queen Hotel. On checking his bill one morning at The Queen, Sir
Blundell detected an error. Not receiving satisfaction from the Queen's manager, he
stormed out threatening to build a hotel which would put The Queen out of business.
And so was born the Majestic: fine hotel as it was and is, it nevertheless failed to
destroy The Queen. Guests have included Elgar, Winston Churchill, Errol Flynn and
George Bernard Shaw.

 The hotel was badly damaged by fire in 1924, causing £50,000 worth of damage.
It also has the dubious distinction of being on the wrong end of one of three bombs
dropped on Harrogate during the Second World War. The hotel was listed as a target
for German bombers in 1940 because German intelligence mistakenly thought
it housed the Air Ministry. In the event a Junkers 88 dropped three bombs on
12 September 1940: one exploded in the hotel gardens, one on the corner of Swan
and Ripon roads, demolishing a house, and the other hit The Majestic but failed to
explode. This was rendered safe by a Captain G. H. Yates of the bomb disposal squad.

THE GARDENER'S ARMS

Bilton Lane, Harrogate, HG1 4DH
Tel: 01423 506 051
http://samsmiths.info/forum/index.php?topic=1606.0

The Gardener's is an old alehouse occupying a building dating from 1698, stone-built,
with stone-mullioned windows, stone-flagged floors and stone slate roof. Time has not
changed its quintessentially eighteenth-century original look, or its essentially domestic
atmosphere. The two main rooms are still either side of the old central entrance
corridor. The parlour, to the right with serving hatch, has solid walls and probably was
the publican's own private 'best room'. The piggery to the left boasts a huge fireplace.
Behind the parlour is a small bar with a snug yet smaller still. The splendid sign
shows a gardener hard at work toiling on his land, flanked by two maidens bearing
the fruits of his labours; the motto reads: 'In the sweat of thy brows shalt thou eate
thy bread.' An outhouse in the large garden once housed the Franklin Brewery, itself
taken over from the pub's original brewery and now the Daleside Brewery in Starbeck.
The tap room, to the left of the corridor, has old bench seating and an ancient hearth.
The rear rooms, including the serving area and the games room, are former domestic
quarters. For most of its history the Gardener's belonged to the Mountgarrett estate,
which finally sold it in the 1970s to long-standing tenant, Maurice Johnson. It has
been in brewery ownership for just over a decade.

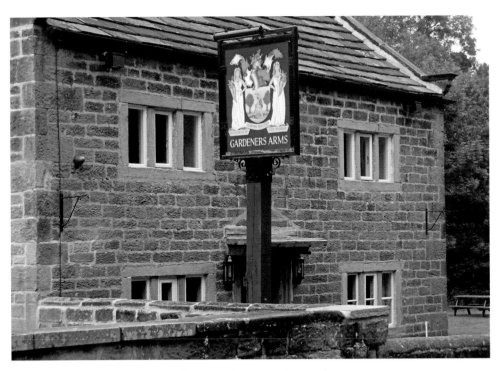

The ancient Gardener's Arms showing the unspoilt interior.

Bilton itself was once a mining village and produced coal for Harrogate's early gas supply. There was other industry in Bilton, workers from which would have gravitated towards the Gardener's: buildings opposite the pub were used to bleach flax for the nearby flax mill.

The pub is one of two in Bilton. The other is The Skipton (formerly the Dragon) on Skipton Road, now closed. The Oak Beck public house on Woodfield Road has been demolished and replaced with eight houses. There is also the former Red Cat Inn, now The Red Cat Cottage, a Grade II listed building. During the Civil War this was an inn on Dragon Lane. The earliest part of the house dates back to the seventeenth century, while more was added in the eighteenth century and the top storey in the twentieth. A red dragon was painted on the outside of the inn, appropriate since as it was known as the Red Dragon. Over time locals thought the dragon looked more like a cat and the pub became known as the Red Cat.

THE HENRY PEACOCK

24 High Street, Starbeck, Harrogate HG2 7JD
01423 883 177

Of the two public houses on the High Street, the Prince of Wales and the Henry Peacock, the latter, originally the Harrogate Hotel, was renamed after the master of the local workhouse during the nineteenth century and is currently closed. The workhouse

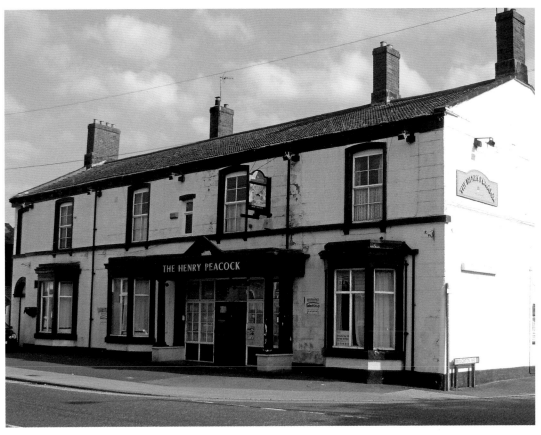

Above: The once proud Henry Peacock on the road to dilapidation.

Right: Peacock feeding the workhouse poor, Dickens style.

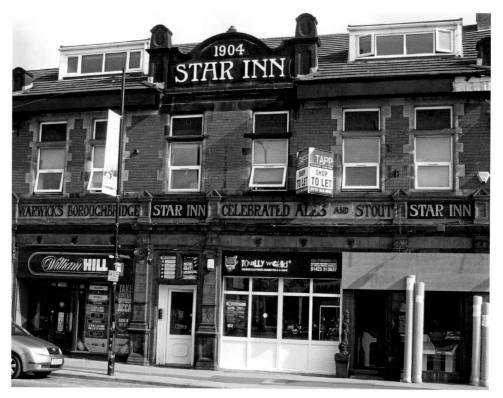

The magnificent Star Inn.

here was known euphemistically as 'The House of Industry' and 'The Castle of Industry'. There is a kind of irony in naming a pub after Peacock when we remember that one of his edicts as master of the local workhouse was the prohibition of alcohol. Nothing unusual about that, but transgression for 'bringing into the house or drinking any spirituous liquor' was met with the toughest of punishments and hypocrisy: transgressors were 'contained in a dark room and allowed nothing but bread and water the next day'. Peacock was dismissed from the workhouse in 1838 and remarried (his wife Jane Dodd had died in 1837); his new bride was a Mrs Waudby, a widow who owned the Brunswick Hotel. It was not long before Peacock soon took over as landlord.

Another Starbeck pub was, appropriately, the Star Inn, the magnificent Edwardian façade of which still towers over the High Street close to Spa Lane. The conspicuous 1904 date was when the new Star replaced the original Star Inn sited there. The 1904 pub lasted until the 1940s when the license was transferred to the Broadacres Inn on the Knaresborough Road.

Over the road is the Prince of Wales, which was originally called the Spa Inn in recognition of the Knaresborough Spa just down Spa Lane. It dates from 1819 and was built to satisfy the less sober thirsts of those coming to Starbeck to imbibe the waters. There are stables and a hayloft at the back. Every Good Friday the pub was cordoned off to the public.

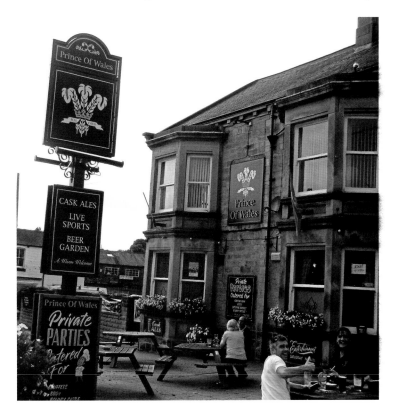

The Prince of Wales and his plume.

In the seventeenth century, Knaresborough was known as 'the Knaresborough Spa', because it was for 'taking the waters' long before Harrogate had developed. This is shown by Dr Deane's *Spadacrene Anglica* (1626) which recommends those staying in Knaresborough to visit not only mineral springs such as the Tewit Well and the Old Sulphur Well, but also those at Starbeck, and the Dropping Well and St Robert's Well and St Mungo's Well at Copgrove.

Knaresborough Spa was really in Starbeck; in 1822 the foundation stone of a new Pump Room was laid by the 'Masons of England' following a procession from the Elephant & Castle in Knaresborough High Street. By 1828, a suite of baths had been added for both warm and cold bathing. It was claimed of those who regularly drank the spa water that 'the digestion becomes amended, the bowels and kidneys perform their functions in a more regular manner … and the skin itself gradually assumes a natural and healthy state'.

Knaresborough Spa never rivalled the mineral wells of Harrogate, with their superior accommodation, and by around 1890 it had closed down. Some of the early buildings can still be seen near the Star Beck on Spa Lane including the later Prince of Wales Baths (1870).

Inevitably, over the years there has been more casualties than just the Henry Peacock. Here are a few more, adapted from http://www.closedpubs.co.uk/yorkshire/harrogate.html.

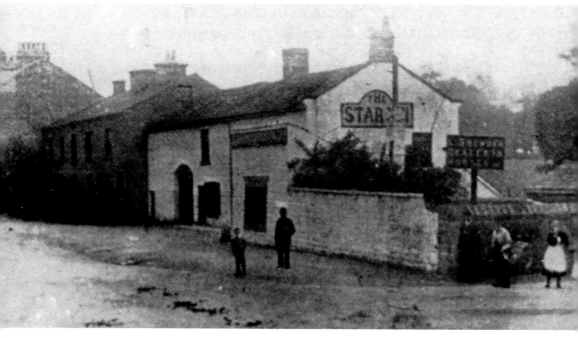

The original Starbeck Star Inn.

Pub	Closed	Location
Exchange	1969	Parliament Street.
Harlow Gate	2009	1 Station Square
Iron Duke		Cold Bath Road
Milepost Inn	2011	Leeds Road.
Nag's Head		13–15 Parliament Street
Star Inn		High Street, Starbeck
Traveller's Rest		Skipton Road

DALESIDE BREWERY

Camwal Road, Harrogate HG1 4PT
01423 880 022

Established in the mid-1980s by a family with a brewing heritage stretching back more than 600 years, Daleside moved to their present premises in Starbeck in 1992. Beers include the award-winning Morocco Ale, Old Legover, Ripon Jewel, and Monkey Wrench; export markets include USA, Canada, Australia, Denmark, Sweden and Spain. Morocco Ale was chosen as the beer to accompany the lamb main course at the All Party Beer Group annual dinner at the House of Commons in July 2015.

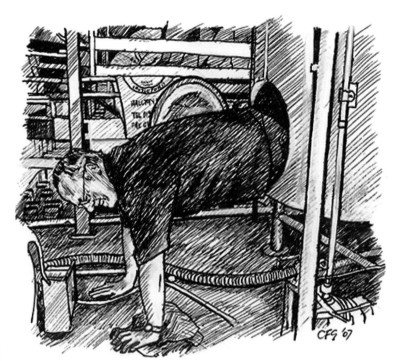

Craig Witty, the head brewer cleaning the copper. (Sketch © Colin Graham)

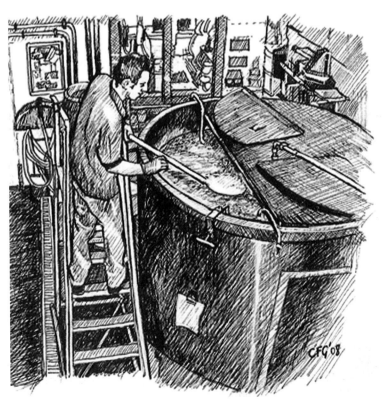

Skimming the Yeast. (Sketch © Colin Graham)

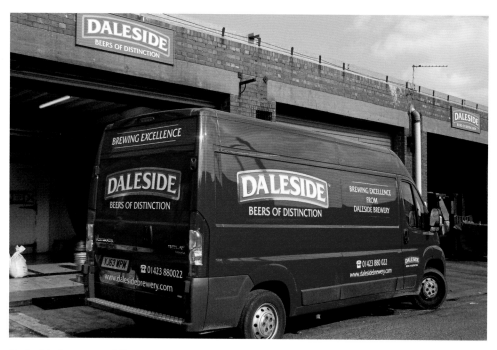

Daleside Brewery delivery van.

THE BOAR'S HEAD

> Ripley, Near Harrogate HG3 3AY
> 01423 771 888
> reservations@boarsheadripley.co.uk
> http://www.boarsheadripley.co.uk/

Ripley is essentially Ripley Castle, the *hôtel de ville* and the old coaching inn, the Boar's Head. A nineteenth-century member of the Ingilby family tore down the existing village and rebuilt it, modelled on an Alsatian village with an *hôtel de ville*-style town hall. The castle and the parish church were all that remained after the 'reconstruction'. The castle dates from the fourteenth century, and has been the home of the Ingilby family for 700 years. The castle – noted for, among other things, a priest hole discovered by chance in 1964 – lies in landscaped grounds that include a deer park and ornamental lakes. King Edward III stayed several times in Knaresborough Castle nearby, most notably in January 1328 after his marriage to Queen Philippa in York. In 1355 he was attacked by a boar that he had just wounded and was thrown from his horse. His life was saved by Thomas Ingilby who slew the beast. Ingilby later received a knighthood, and a boar's head was henceforth included in the Ingilby coat of arms and provided the name for this Ingilby-owned hotel and bar. The name above the door is Sir Thomas Ingilby Bt.

Boars are everywhere: a stone one stands in the village and a stuffed one called Boris looks down from on high as you enter the pub. The history of the Ingilbys is recorded

on boards above the bar. Boris is not alone: among other aristocratic paraphernalia in the bar is a display of vintage sporting gear, cricket bats, ice skates, tennis racquets, while graffiti on the walls include cartoons of dancing pigs.

There were once three pubs in the village, but Ripley was dry for most of the twentieth century after the Bible-thumping Sir William Ingilby objected in 1919 to the pub's opening after Sunday church. The landlords dug in their heels and refused to observe six-day openings, so he closed all of them down in an act of Cromwellian spite. The last landlord was Yorkshire and England cricketer Franks Smailes who, in despair, threatened to cut down the picturesque Virginia creeper growing on the outside of the pub; Ingilby took him to court to restrain him. The Boar's Head, originally called the Star Inn when it was the first stop on the express coaching service between Leeds and Edinburgh, finally reopened in 1989. According to the *Yorkshire Evening Post*, the Boar's Head is 'inevitably known locally as the Whore's Bed, though the rooms here are available by the night, rather than the hour'.

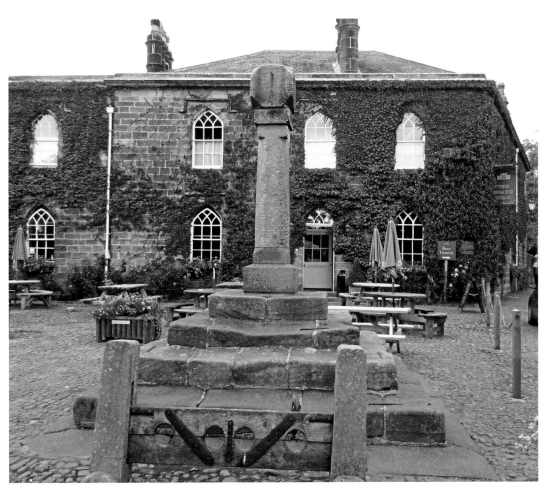

The Boar's Head with village cross and stocks in the foreground.

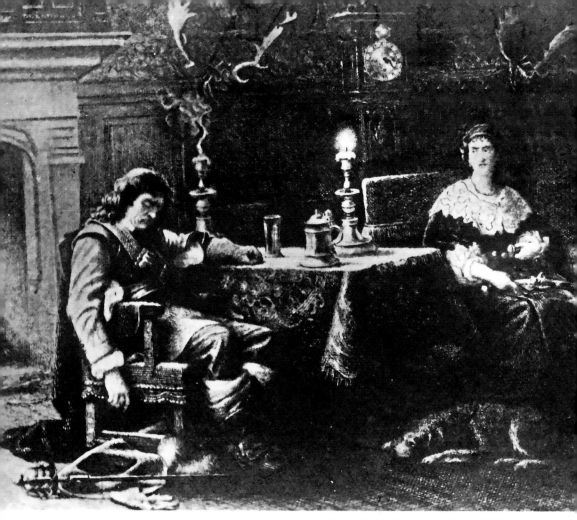

CROMWELL & DAME INGILBY, RIPLEY CASTLE.

A heavily armed and angry-looking Jane Ingilby and dog guarding Oliver Cromwell, somewhat worse for wear for ale and civil warring.

ROYAL OAK

Oak Lane, Dacre Banks, Harrogate HG3 4EN
01423 780 200

The original pub here dates from the Middle Ages when it belonged to Fountains Abbey before it was sold to the Ingilby family. The Ingilby bailiff installed himself at the pub on quarter days to collect the tenants' rents. The current inn dates from 1752 while the coach house is older still. Apart from being an important coaching inn, the pub enjoyed a lively trade from cattle and sheep drovers bringing their livestock from Wharfedale. In the nineteenth century, Catholics used an upstairs room to hear Mass. The Ingilbys sold the pub and its 24 acres in 1919 to pay death duties.

THE GENERAL TARLETON

Boroughbridge Road, Ferrensby, Harrogate HG5 0PZ
01423 340 284
gt1@generaltarleton.co.uk
http://www.generaltarleton.co.uk

A former eighteenth-century coaching inn, named after the notorious, or famous, British general who fought in the American War of Independence. It was claimed that General Sir Banastre Tarleton was guilty of massacring Continental Army troops at the Battle of Waxhaws who were in the act of surrendering; he became known as 'Bloody Ban' and 'The Butcher' – a nickname which has stuck in popular culture for rebel propaganda purposes. The Loyalists and British regarded Tarleton as a skilful leader of light cavalry and praised him for his tactical prowess and determination even against superior numbers. His green uniform was the standard of the British Legion, a provincial unit put together in New York in 1778. Tarleton was later elected an MP for Liverpool and became a leading Whig politician. His cavalry went by the name of Tarleton's Raiders.

In 1876 the General Tarleton was the scene of an alcohol-fuelled disturbance which was to have fatal consequences for landlord Robert Gibson. On the morning of 22 May four thirsty militiamen from the 5th Yorkshire Militia turned up and ordered a quart of beer. When it came to pay they were reluctant to stand the 6d charged and said they would only pay 4d. Gibson protested and refused to serve them any more beer. The militiamen became rowdy and started singing and dancing but eventually left without further ado. However, a fight later ensued and Gibson was hit by one of the soldiers, Bartley, striking his head on the ground – a trauma which obviously incapacitated him. He was carried back into the General Tarleton and lapsed into a coma; he died the following morning. An inquest at the Blue Bell Inn in Arkendale found Bartley guilty of manslaughter. He was sentenced at Leeds to seven years penal servitude.

The General Tarleton was the scene of another inquest in March 1881 when the body of a baby was found in the icy village pond. It was discovered by Arthur Wade, the fourteen-year-old son of the innkeeper Robert Wade, while he was out breaking the ice. The baby girl was facedown, muddied, naked and was in eight inches of water where she had been for some days. The coroner, William Renton, could find no obvious signs of violence; the post mortem confirmed that the child was dead before she entered the water and the mystery surrounding her fate remains to this day.

THE CROWN

Crown Hotel, Horsefair, Boroughbridge YO51 9LB
01423 322 328
sales@crownboroughbridge.co.uk
http://www.bw-crownboroughbridge.co.uk

In 1569 The Crown was the manor house of the aptly named Boroughbridge MP William Tankard and was used as a rendezvous for the Council of the North where the earls

Above: The Crown today with cartwheel on the wall.

Below: The three greyhounds magnificently restored.

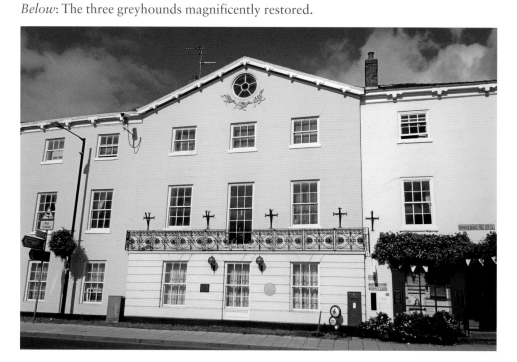

of Northumberland and Westmoreland conspired to set Mary Queen of Scots on the throne. It became one of the premier coaching inns on the route from York to Newcastle.

The Three Greyhounds Hotel was next to the post office on Horsefair, and is now converted into flats; this coaching inn was known for its Whig affiliations while the Tories patronised The Crown opposite. The Three Greyhounds was once the home of the Mauleverer family, and you can still see the three splendid greyhounds taken from the Mauleverer coat of arms. Before that it was known as the Muskateer, and then the Mauleverers Arms. There is another old coaching inn called the Crown Inn at nearby Roecliffe.

THE BLACK BULL

St James' Meadow, Boroughbridge, York YO51 9AR
01423 322 413
www.blackbullboroughbridge.co.uk

The Black Bull Inn dates back to 1258 but it was later a major player in the refreshment, logistics and hospitality business on the busy Great North Road (today's A1M). Locally, it was an important stop on the Thirsk–Harrogate run. Ancient beams dominate and ghosts are rampant, not least the one with a penchant for table relaying who reorganises glasses

The Black Bull today.

and napkins set for the following morning's breakfast service. The police were called one night when a guest was alarmed to see a figure disappearing through his bedroom wall. Yes, there is a late bar.

THE SHIP INN

> Low Road, Aldborough YO51 9ER
> http://shipinnaldborough.com

The Ship's interior can still boast a good deal of seasoned, hard old timber which may well have come from ships. As with the Ship Inn at Strensall with the Foss Navgation, the pub echoes the importance of the river traffic here downstream from Boroughbridge. The Ship may once have been a monastic or church rest house, serving St Andrew's church opposite. The hostelry probably grew out of a sixteenth-century farm which had its own beerhouse-cum-brewery. The Ship may be the pub mentioned in the Aldborough parish records for 1596, when a man hired a gun from another man in a pub, gave him tuppence to fire a shot, crossed the road over to the church and took a pop over the minister's head . The shot thankfully missed but achieved its intention of putting the fear of God in the minister.

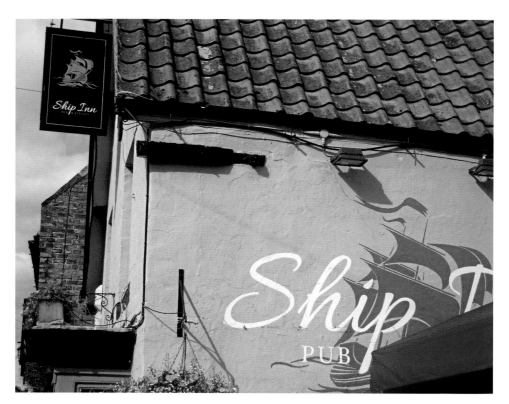

The apparently landlocked Ship Inn.

We know that it was known as The Ship in the seventeenth century, evidenced by a token copper coin in existence, dated 1671, which shows a ship in full sale with the inscription 'John Briggs in Aldborough his half penny'. We know of a John Briggs who owned an acre of land in Aldborough at that time. Traders and landlords often issued small copper coins in the reign of Charles II when small change was in short supply. The antiquary William Smith, writing in 1884, believed that the coin depicted The Ship at Aldborough. The Blackburn family ran the inn for more than 130 years: Thomas Blackburn in 1712, another Thomas Blackburn in 1747, his son Richard in the early nineteenth century and Ellen Blackburn as late as 1844. It would be nice to think that these Blackburns were related in some way to Lancelot Blackburne – the archbishop and pirate who died in 1743; he was Archbishop of York from 1724 until his death, before which he did time as a paid spy for Charles II in 1681, and as a pirate in the Caribbean in the 1680s. He reputedly swigged ale and smoked a pipe during confirmations, behaviour typical of the man and famously described as follows: 'His behaviour was seldom of a standard to be expected of an archbishop ... in many respects it was seldom of a standard to be expected of a pirate.'

In the nineteenth century there were two cottages adjacent to the pub. A May 1870 sale notice describes The Ship as an inn or public house with brew house, wash house, cart sheds, stables and garden, two cottages with stables, piggery and garden. The cottages were later knocked down to make way for the car park. Apart from the woodwork from the ships, the pub maintains a nautical atmosphere with a ship's wheel and prints on display inside.

THE MASON'S ARMS

St. John's Road, Bishop Monkton, Nr Harrogate HG3 3QU
01765 676 631
masonsarmsbishopmonkton@btconnect.com
http://www.themasons-arms.co.uk/about

The village of Bishop Monkton dates back over a thousand years when it was settled by Scandinavians who came over the North Sea and travelled up the Ouse via York. The first record of Bishop Monkton dates back to 1030. In 1086 it was mentioned in the *Domesday Book* as being part of the manor of Ripon. The village has never been short of pubs, as the village website (http://bishopmonktontoday.btck.co.uk) informs us: 'Anchor Inn, now Anchor House, a private residence on the way out of the village on the Roecliffe road. This was much frequented by farm workers, including those from Westwick Farm, workers in the Corn Mill (formerly the Flax Mill), estate workers from Newby Hall, as well as workers in the gravel quarry and bargees bringing coal up "the cut".'

The last licensee at the Crown Inn, now a private house on the Boroughbridge Road, also ran a butcher's business in part of the premises. The Star Inn was a coaching inn on the Knaresborough Road at the junction with St John's Road. The last occupant was Mr Mears who also ran a coal merchant business and a transport service collecting and delivering milk and other provisions. The Coach & Horses was at the top of Moor Road. The Dove was in what is now Monkton Mains Farm where the Burton Leonard road branches off from the Harrogate–Ripon road. The two pubs still serving are the Lamb & Flag and the Mason's Arms.

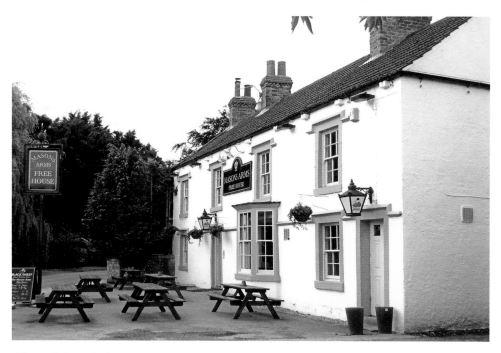

Above: Mason's Arms.

Below: Country village scene around the Lamb & Flag. Lamb and Flag was an heraldic sign and might refer to Knights Templar, merchant taylors and many others. The lamb was the Lamb of God.

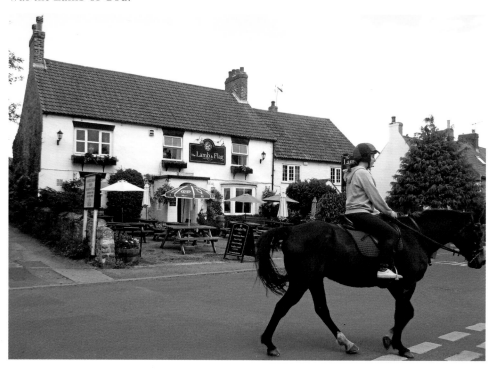

HARE & HOUNDS

Mill Lane, Burton Leonard, Harrogate, HG3 3SG
01765 677 355
http://hareandhoundsburtonleonard.com

This village pub has been haunted over many years; there were reports of a child being involved in these mysterious activities. One night, the fire alarm went off and the proprietor rushed downstairs, expecting to find mayhem and disaster. He opened the kitchen door and there was no fire, no smoke. However, the floor was awash with water from the sprinklers. He mopped up the mess and, as he was going back to bed, heard a child laughing. However, there was no child staying at the inn that night. The village name is Old English for burh-tun – a fortified farmstead.

THE BLACK SWAN

Burn Bridge Road, Burn Bridge, Harrogate, HG3 1PB
01423 871 031
info@theblackswanpub.co.uk
http://www.blackswan.mebdev.co.uk/about

This Victorian pub has a Victorian air about it; there are plans on display which date back to the early 1900s although the original pub dates from 1650. It is known locally as the 'Mucky Duck'. There has been an inn on the site since itinerant charcoal burners used it in around 1650 to slake their thirst. The blacksmith's used to be opposite the pub on Burn Bridge Road; it later became a grocer's shop until the 1960s and is now an office. Burn Bridge may get its name from the charcoal burners, or else the wooden bridge across the River Crimple which was burnt down at one point.

Beer was brewed locally. There was a malthouse nearby, in what is now Malthouse Lane. The malthouse was built around 1876 by a farmer, Thomas Hudson, who bought the land from local landowner Eliza Penelope Bentley of Pannal Hall. Wagons brought in coal and barley from a railway siding; you can still see the containing wall for the coal by the Harrogate Line. The malthouse was knocked down in 1975, but the malthouse manager's house still survives, as does the cobbled yard which was the malthouse coal yard – steps once led down from the coal yard to the boiler room and river. The site is now occupied by four houses, built in 1975.

In 1646 Charles I was riding along the Leeds–Ripon road here on his way from Newcastle to London when his high crowned hat was knocked off by the low hanging branch of an ash tree. The tree's owner, a Royalist, had it felled immediately.

THE KESTREL

> Wetherby Road, Plompton, Knaresborough, HG5 8LY
> 01423 797 979
> http://www.vintageinn.co.uk/restaurants/yorkshire/
> thekestrelharrogate

The village of Plompton was originally owned by Eldred de Plumpton, who passed down the ownership of the hamlet over seven centuries through successive generations of his family. When it opened The Kestrel was only the second inn to open in the area. Nearby Plompton Hall was designed by York architect John Carr.

The local tourist attraction that is Plumpton Rocks is an artificial lake with surrounding pleasure gardens laid out in 23 acres by Daniel Lascelles against a backdrop of imposing wind-blasted rocks. These striking millstone grit rock formations have been christened with names such as Lion's Den, Lover's Leap and Needle's Eye. The lake was extended by a dam built by Carr. In 1797 Turner was commissioned by Edward Lascelles, 1st Earl of Harewood, to produce two paintings of the lake and rocks; they are now in Harewood House. These were Turner's first commissioned landscapes in oils painted before he achieved fame and explain why he charged the earl as little as £32 for the pair. Both are known as *Plompton Rocks*: one is of the lake head looking south, with a fisherman on the lake while the other is from the dam looking north, with a fisherman packing up for the night.

THE SMITH'S ARMS

> Church Row, Beckwithshaw HG3 1QW
> 01423 504 871
> http://www.chefandbrewer.com/pub/smiths-arms-
> beckwithshaw-harrogate/c1934

The Smith's Arms in early days.

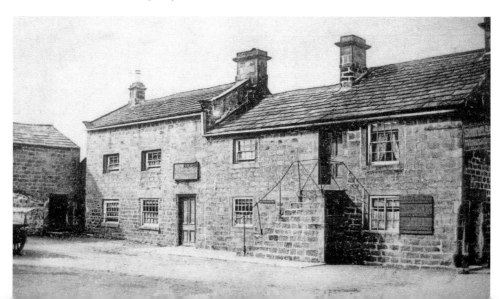

This eighteenth-century inn can be found on the old turnpike road from Otley. Originally a working blacksmith's forge, the pub gets its name from the terms of the original tenancy agreement: the landlord was the local blacksmith who also had an obligation to provide food and drink to the local community and to passing travellers. Until the 'National School' was built in 1865, the pub's upper room also served as a schoolroom and you can still see the imprints on the external steps the children used to climb to get to the classroom.

THE SQUINTING CAT

Whinney Lane, Lund House Green, Harrogate HG3 1QE
01423 565 650
http://www.fayre-square.com/pub/squinting-cat-harrogate/m6308/?utm_source=g_places&utm_medium=link&utm_campaign=pubs

One of Britain's more intriguing pub names, the Squinting Cat in Pannal was built around 1720 as a smithy but converted to a coaching inn in which the dining room was used to repair coaches. The name derives from a former landlady known as 't'owd cat'. She was in the habit of squinting out of the window from behind the curtains to scrutinise customers as they approached; in doing so she gave the pub its nickname. So, in 1930 when the pub was refurbished it was renamed the Squinting Cat. Recent modernisation has erased all of the pub's innate charm and character.

There are many other feline-inspired pub names, not least the Red Cat Inn, in Harrogate. The Cheshire Cat at Ellesmere Port is the first reference we have (from 1770) to the phrase 'grinning like a Cheshire Cat'; the Burmese Cat in Melton Mowbray is a result of a brewery chairman whose wife bred Burmese cats. There is a Whittington & Cat in London and one in Hull in deference to Dick, and to his cat with Puss in Boots. The Cat and Bagpipes is however, devoid of cat, derived from the Latin *catphractes*, cavalry troops who wore iron breastplates, body armour adopted later by Scots border bandits. In the days of the border raids the skirl of bagpipes evoked the warning cry 'The Cats are coming!' The name and sign are a throwback to these times.

There was a White House at Mill Lane, Pannal, complete with brewery taken over by Kirkstall Brewery during the First World War. The recently demolished nineteenth-century Spacey Houses Hotel and pub was on the Pannal side (west) of the A61, named after the coaching inn on the Spacey Houses side, or east side, of the road, which had been converted into a farmhouse and is now private housing. The hotel had its own brew house, the Old Spacey House Brewery Pannal, owned by J. Holmes throughout the 1900s. It was all sold to Tetley's in 1960. The name Spacey is from the Spacey family who lived in the farmhouse. The baptismal register for Kirkby Overblow in the 1470s features the christening of Roger, son of George and Isobel Spacey. As it happened, the farm was also an inn thought to have been used by monks travelling to and from Fountains Abbey. Blind Jack was also a patron during his time here, surveying and building

the road. He also imbibed at the Ship Inn, still to be seen at Harewood Bridge, although it is now a private dwelling.

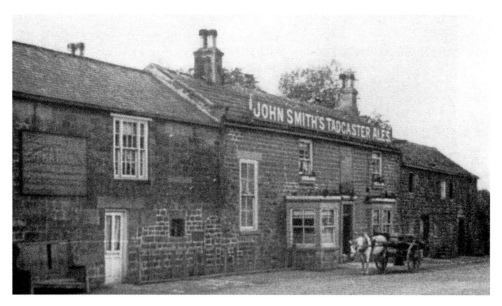

The early Spacey Houses.

The last Spacey Houses.

GUY FAWKES ARMS

Main Street, Scotton HG5 9HU
01423 868 400
http://www.guyfawkesarms.co.uk

There used to be four pubs in Scotton. The Bay Horse pub can be seen on late nineteenth-century Ordnance Survey maps down the road from the Star Inn, now known as the Guy Fawkes Arms, roughly opposite the Methodist chapel. Then there was the George IV and another, on the junction of Ripley Road and New Road leading into Scotton called the Fox & Hounds.

Born in York in 1570, Guy Fawkes moved to Scotton in his late teens when his widowed mother married Dionis Baynbrigge (Dennis Bainbridge) of Scotton, a Catholic who resided at Percy House, Scotton, and also at Scotton Old Hall. Guy had been brought up a Protestant, but the illegal Catholic religion of his new relatives led to his conversion. In 1593 he moved south, and eventually joined the Spanish Army then fighting in the Netherlands. As Captain Guido Fawkes he had a distinguished military record, and his expertise with explosives attracted the plotters in their attempt to assassinate James I. It has been claimed that the plot was made around a table in a Knaresborough inn. Guy Fawkes, under the pseudonym Johnson, a servant to Thomas Percy, smuggled thirty-six barrels of gunpowder under the House of Lords, in time for its royal opening on 5 November 1605. Just before midnight, he was arrested, 'booted and spurred', about to flee, with a watch, lantern, tinderbox and slow fuses. He was 'interviewed' by King James in his bedchamber, taken to the Tower to be tortured, and finally 'hanged, drawn and quartered' as a traitor on 31 January 1606. Though his effigy is still burnt on 5 November ('Plot Night', as it is called in parts of Yorkshire), no guy is ever burnt at St Peter's, his old school in York, or on the public bonfire in Scotton.

Guy Fawkes today.

THE TRAVELLER'S REST

Crimple Lane, Follifoot, Harrogate, HG3 1DF
01423 883 960
travellersrestharrogate@outlook.com
http://www.thetravellersrestharrogate.co.uk

The name Follifoot is derived from Old Norse translating as 'place where the horse fought' – the beginning of a long association with horse sports. The earliest record is 'Pholifet' from the twelfth century. Anglo-Saxon remains have been discovered in and around the village and an Anglian cross stands at the crossroads at the top of the village. In the nineteenth century the village was a thriving community with its flax industry, tannery, tailors, joiners, a wheelwright, cordwainer and blacksmiths.

Nearby 2,000-acre Rudding Park exists from the eighteenth century. Follifoot suffered an attempted 'land grab' when Daniel Lascelles purchased land and cottages in Follifoot from a Dr Hodgson for £1,000. He proceeded to continue the illegal practice adopted by the doctor, of holding a 'manor court'. To get villagers to attend, Lascelles held the court not in a 'place of ancient use' as was usual, but in the local alehouse where the customary hospitality was liberally dispensed. One veteran Follifoot freeholder, a Mark Park, when asked why he and others attended this illegal court, replied, 'I cannot tell why, but that we are always handsomely treated and it is the best court I ever was at.' The village's other pub is the Harewood Arms.

THE CASTLE INN

High Street, Spofforth HG3 1BQ
01937 590 200

The Castle Inn, is, of course, named after the fourteenth-century castle which stands here. Spofforth has enjoyed three other pubs over the years: The Railway, the William IV, which closed in the early 2000s, and the long-gone Prince of Wales. Spofforth Castle was built by Henry de Percy in the early fourteenth century when he was granted a licence to crenelate a manor house on the site; further alterations were made in the late fourteenth and fifteenth centuries. The Percy estates were confiscated after the rebellion against King Henry IV in 1408 and given to Sir Thomas Rokeby. They were later restored to the Percys and then lost again in 1461 when they backed the losing side in the War of the Roses. Spofforth was again later returned to the family, this time until 1604. The castle was slighted during the English Civil War.

THE RAILWAY INN

Park Terrace, Spofforth, HG3 1BW
01937 590 257

The railway arrived in Spofforth in 1847 with the opening of the Harrogate to Church Fenton line. Spofforth was the only intermediate station between Wetherby York Road station and Harrogate station. The line closed to passengers in 1964 and to goods in 1966 as part of the Beeching reforms. The pub was converted from two railway cottages.

SCOTTS ARMS

Main Street, Sicklinghall, LS22 4BD
01937 582 100
http://www.scottsarms.com

The pub dates back as far as 1685 and is the result of a devastating fire which tore through Sicklinghall. The Scott family, principal landowners in the area, built the inn as part of the reconstruction of the village; their philanthropy endured through to the nineteenth century when they built the village school and provided other benefits to the community.

The Scott family lived at Woodhall, now a hotel, the home of Lord Sicklinghall from medieval times. The Scott family motto was '*non invite minerva*' – 'do not envy my wisdom' – wisdom that many would have agreed was implicit in building a new pub for the village. With the advent of coach travel in the eighteenth century, the Scotts Arms found itself on a busy route between Harewood, Wetherby and Harrogate. In the mid-eighteenth century the name of the inn changed to the Middleton Arms as a result of a land deal between

Follifoot's Harewood Arms.

the Middleton and the Scott families which saw the latter benefit over the Scotts. The Middleton age however, was short-lived and ten years later the Scotts Arms was the name on the sign again.

Apart from patronage by cast and crew working on *Emmerdale* nearby at Harewood, there are frequent spiritual visitors. The pub's website tells us that 'according to a number of mediums who all individually give the same information, we have several ghostly spirits, orbs caught on camera, bumps and bangs, footsteps and flickering lights. Will and Dave from the 1840s, local gravediggers, still pop in and sit at their favourite seats on the back wall at our table 18. Mary dressed in a large bonnet, dark rough long dress still milks cows in the barn, now our shop. A young girl named Annie is often seen in the small room to the right was the blacksmith's daughter. She told how she died in 1640 aged eleven years old of fever and cold, probably flu. There is an elderly couple who still sit at our table 30, both dying of TB in the late 1800s. We have a soldier and his dog from the civil war seen walking through the pub in full military uniform'.

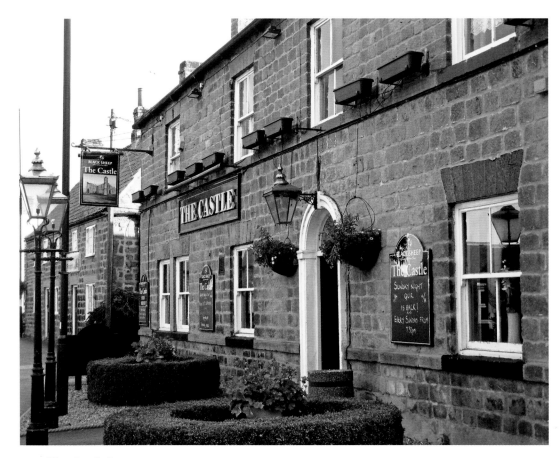

The Castle Inn.

Part Two
Knaresborough

Knaresborough has long been famous for its number of inns – seventy-four are recorded during the eighteenth and nineteenth centuries. *Baines Directory* of 1822 lists thirty-nine pubs and inns in the town. For the most part they did good trade, especially on market days and during election campaigns. Many provided accommodation for spa visitors and travellers, as well as fulfilling their role as social centres for residents, with some offering cockfighting. Many of these inns no longer survive. They include The Barrel, the Elephant & Castle, the Star Inn, two called the White Horse, and the Shoulder of Mutton. Others have been rebuilt, such as the World's End (1898), or replaced by a modern building on the same site, for example the Ivy Cottage. Some, happily, have remained almost unchanged over the centuries, in particular the Old Royal Oak, the Mother Shipton (once called the Dropping Well), the Half Moon, The Crown, the Hart's Horn, the Marquis of Granby, the Borough Bailiff (once called The Commercial and now The Commercial again), the George & Dragon, and the Yorkshire Lass (formerly the George Hotel and the Murray Arms). The little elephant in Silver Street used always to be spelled with lower case throughout, its sign an illuminated Disney Dumbo flying over rooftops.

Here is a fullish list, adapted from www.closedpubs.co.uk/yorkshire/knaresborough.html, of those that are no more.

Pub	Closed	Location
Barrel Inn	1915	High Street
Black Bull	1906	High Street
Black Horse	1915	Market Square
Black Swan	1893	High Street
Brewer's Arms	1909	Fisher Street
Crown & Cushion	1922	Bond End
Elephant & Castle	1962	High Street
Encore Vaults	1906	High Street
Eugene Aram	1910	High Street
Golden Anchor	1932	High Street
Green Dragon	1910	Cheapside
King's Arms	1961	High Street
Ivy Cottage		Stockwell Lane
Lord Nelson	1906	Hilton Lane
Nag's Head	c.1970	Cheapside
Parmassus Mount	1914	Kirkgate

Queen's Arms	1922	Kirkgate
Red Bear	1909	High Street
Red Lion	1909	High Street.
Robin Hood		112–114 Briggate
Royal Oak	1994	Now a house
Shoulder Of Mutton	1921	High Street
Star Inn	1906	Abbey Road
Station		Kirkgate
Straw Boater	1970s	Abbey Road
White Horse Hotel	1928	Finkle Street
Yorkshire Lass		Harrogate Road

As for the Crown Hotel in the High Street the photograph from the early 1900s shows the wood-panelled room in the Old Oak Room at The Crown. Around this time The Crown boasted an impressive external clock owned by Tetley's and the landlord was a W. Broadley. It was the town's main coaching house and commercial inn.

There was a Vaux 'pub' on Harrogate Hill which was replaced by the now derelict Yorkshire Lass pub on the right of the road as you leave town.

The Star Inn in Abbey Road can be seen on the left of the photo on page 74 and Horsman's the rug maker. This road led to the friary (the Trinitarian House of St Robert) which stood just under the Chapel of our Lady of the Crag. The original priory was razed in 1318 by the armies of Robert Bruce but rebuilt by Edward III. In 1366 Archbishop

The Robin Hood at the foot of Briggate.

The old Half Moon.

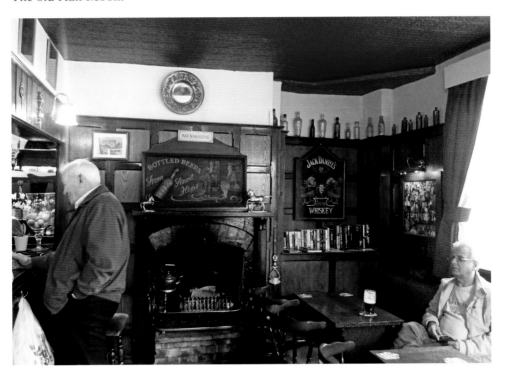

Thoresby decreed 'that in future the cloister and dormitory should be kept free from the invasion of secular persons, and especially women of doubtful character, both day and night'. Robert Ashton, one of the ringleaders of the Pilgrimage of Grace, was a friar here in the 1530s.

As in Harrogate, Knaresborough pubs were not always just about drinking. Some had serious official business, some were implicated in deeply nefarious business. The Horse and Groom was the setting of many meetings held to thrash out the details of the enclosure of surrounding land in 1768.

The White Horse in the High Street was famous for the notorious Eugene Aram scandal. Born at Ramsgill in Nidderdale in 1704, Aram moved to Knaresborough in 1734 and opened a school, in White Horse Yard (now Park Square). A self-educated scholar and linguist, he got mixed up in a fraudulent scheme with a flax-dresser, Richard Houseman, and a young shoemaker, Daniel Clark. On 7 February 1744, Clark disappeared, it was assumed he had absconded with some valuables. Soon after, Aram paid off his debts and left Knaresborough. In August 1758, a skeleton was discovered buried on Thistle Hill. Houseman, accused of Clark's murder, denied that the remains were Clark's and eventually confessed that he was actually buried in St Robert's Cave, where he had allegedly seen Aram strike Clark down. Traced to King's Lynn, Aram was arrested and imprisoned in York Castle. Despite his learned defence, he was found guilty at York Assizes and, on 6 August 1759, condemned to be hanged in York, his corpse later stuck on the gibbet just beyond the Mother Shipton Inn. The beam from which Aram's body was hanged in chains was later used in the construction of a room in the Brewer's Arms Inn, much to the ongoing delight of patrons.

Two writers popularised Eugene Aram: Thomas Hood, in *The Dream of Eugene Aram*, which vividly describes Aram's guilty conscience, and Bulwer Lytton in a fanciful novel, *Eugene Aram*, which attempts to exonerate him.

The White Hart, a small pub in the marketplace, was tainted with a similar reputation to the White Horse. In 1841 Joseph Cocker was landlord there, a widower who lived alone. One night in June three Knaresborough men called in for a drink. The intention of John Burlinson was to rob the pub, with a little help from his friends Henry Nuttall and Charles Gill. When Cocker refused to serve them – they had already consumed five pints – Burlinson hit him on the head with a hammer; the landlord pleaded with them not to murder him. The robbers suggested concealing Cocker down in the cellar – all of this was witnessed by a Mrs Snow, a daring lady from next door who had heard the commotion and went to look through the window. Gill struck Cocker four or five more times with the hammer. After robbing Cocker, the men fled down Jockey Lane (the Synagogues) onto the High Street to High Bridge, from where the hammer was dispatched to the River Nidd. Meanwhile Mr Snow collected his pistol and summoned David Vickerman, a policeman. In the pub they found a blood-soaked Cocker with a poker lying next to him and the walls blood spattered. Thomas Beaumont, the surgeon, was called but could not save him. All three robbers – murderers now – were arrested later that night and relieved of their blood-soaked clothing, which was later used as evidence. All three were sentenced to death by hanging at York.

Two early Freemason lodges existed in Knaresborough – the Crown Lodge (consecrated in 1769), which met at The Crown, and the Newtonian Lodge (consecrated around 1785), which met at the Elephant & Castle. Then there were the Friendly Societies. As well as the Foresters and Oddfellows, Knaresborough had other mutual aid societies by the 1890s, including the Druids, who met at The Crown, and

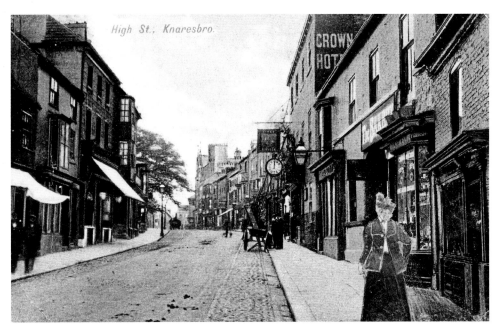

The Crown dominating Knaresborough's High Street and telling the time.

Inside The Crown.

the Free Gift, which met at the Queen's Arms in Jockey Lane. From 1919, the Royal Antediluvian Order of Buffaloes began meeting in the Wellington, then the Hart's Horn, and finally The Crown.

The Elephant & Castle was where an inquest was held in 1853 to establish the cause of death of eighty-three-year-old Hannah Bramley. This inquest however was somewhat unusual because Mrs Bramley had already been buried. She was exhumed on the suggestion of various scandal-mongers that she had died at the hands of her daughter, 'a woman of dissolute habits'. The surgeon performed a post mortem which revealed that death was due to inflammation of the lungs and not because of any physical abuse. Mrs Bramley was reinterred.

Two years later in 1855 the common law marriage between Jean Lund and Edwin Harrison came to a nasty end in the Dog & Pheasant in Knaresborough. Harrison had deserted Lund, leaving her with their three children and married another woman in Hull. The newly married couple made the mistake of returning to Knaresborough and faced the scorned Jean Lund in the pub. She had heard of their visit and armed herself with a jug of vitriol, or sulphuric acid. This she threw at Mr and Mrs Harrison causing serious burns to Mrs Harrison's face and arm, and to the landlady, a Mrs Ware. Lund, herself burnt by the acid, was arrested and protested that she had wished to 'burn Harrison's heart out'. Although found guilty, the judge showed mercy when he sentenced her to one year's jail.

In 1858 the badly mutilated, almost decapitated, body of Mary Jane Scaife was taken to the New Inn in Darley to await the coroner. The murderer, James Atkinson, was refused permission to give his 'sweetheart' one last kiss.

In January the following year farmer, William Goodyear went to Knaresborough market as usual. On his way home to Whitewall near Hampsthwaite he gave a lift to

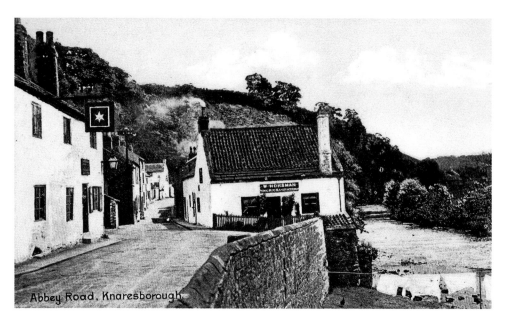

A very old Star Inn in Abbey Road.

Above: This Knaresborough shop in Church Lane around 1898 is an early off-licence, selling as it does ale and porter as well as the usual tobacco, chocolate and sweets. The picture shows Mrs Wheelhouse and daughter Florence.

Right: It wasn't all just about drinking: pubs were sometimes the venues for serious business.

THE

KNARESBOROUGH

BENEVOLENT

FUNERAL BRIEF,

HELD AT THE HOUSE OF Mr. JOHN LEE,

THE GEORGE & DRAGON INN

BRIGGATE, KNARESBROUGH.

SPECIAL REPORT.

KNARESBROUGH.
PARR, PRINTER, MARKET PLACE.
1878.

a man walking between Knaresborough and Starbeck. Around midnight they stopped at the Nelson Inn at Saltergate to get some food and drink. On resuming their journey Goodyear was attacked and robbed. James Fould, the assailant, was later sentenced to three years' penal servitude on the evidence of the landlord at the Nelson, a Mr Frankland.

Pubs, of course, had an important role to play in parliamentary elections, and the drinking places of Knaresborough were no exception. 'Treating' – where candidates seduced potential voters with free beer – was as rife here as anywhere. The political situation in 1866, one year before the Reform Act sorted it all out to a large degree, was as anomalous as the provision of opportunities for alcohol consumption was prodigious. Knaresborough, with a dwindling population and one of the smallest electorates in the country with 260 voters, returned two members, just like Leeds with over 9,000 voters and one more than Huddersfield with 2,000 voters. *Kelley's Directory* for 1866 lists thirty-eight inns and five beer shops in Knaresborough so the competition for the lucrative treating trade must have been intense. As a parliamentary candidate, wherever you placed your tab behind the bar must have been a sure-fire vote winner among the lucky drinkers. In the 1880 election the Conservative and Liberal Working Men's Clubs were awash with beer. The latter had a non-liquor rule but got round this by depositing eight barrels of beer at the caretaker's house next door. The Tories despatched thirty members in groups of five or six with authority to spend a minimum of 10s on treating in the town's pubs. The final tally of £22 14s

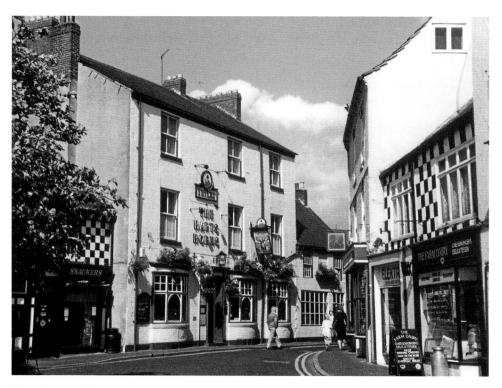

The Hart & Horns.

11*d* was paid without demur, despite claims by the candidates that they knew nothing about the practice.

At the time of writing, Knaresborough Civic Society had placed seventeen plaques to mark buildings of significant historical interest around the town. One, The Mitre, originally The Wheatsheaf, changed its name to The Mitre in 1923. Bishop William Stubbs (1825–1901) was born here; he rose to become a distinguished theologian, an important church historian and the Bishop of Oxford. The Wheatsheaf was the birthplace of George A. Moore CBE, KStJ, industrialist and businessman who supported the town through many local causes.

MARQUIS OF GRANBY

York Place, Knaresborough HG5 0AD
01423 862 207

The first pub when approaching Knaresborough from the south. Lieutenant-General John Manners, Marquess of Granby PC (2 January 1721–18 October 1770) was commander-in-chief of the British army from 1776 to 1770 and an MP for Grantham from 1754 to 1768. When Granby, serving in the Blues and Royals, was sent to Paderborn in northern Germany to command a cavalry brigade he led a charge at the Battle of Warburg and is said to 'have lost his hat and wig, forcing him to salute his commander

Humour at the Marquis of Granby, one of the best old pubs in Knaresborough with cosy, homely rooms and no televisual blitzes .

without them'. This instigated a British Army tradition whereby non-commissioned officers and troopers of the Blues and Royals are the only British Army soldiers who may salute superior officers without wearing headdress.

Granby was one of the first commanders to appreciate and understand how crucial welfare and morale were for the troops. Most of his portraits show him mounting a horse, or helping the wounded. The reason why he so frequently appears on pub signs is his philanthropy: he gave financial assistance to many of his wounded soldiers to start a new life and help them set up as innkeepers.

THE BOARD INN

3 High Street, Knaresborough, HG5 0EN
0871 951 1000

The Board dates back to the 1630s and, as the pictures show, is now a shrine to all things Leeds United and vinyl. The name would have clearly indicated to travellers arriving in Knaresborough from the York road that, apart from a bed, cold meats were available here – served on wooden boards, hence the phrase board and lodge. The pub features some attractive Tower Brewery stained-glass windows.

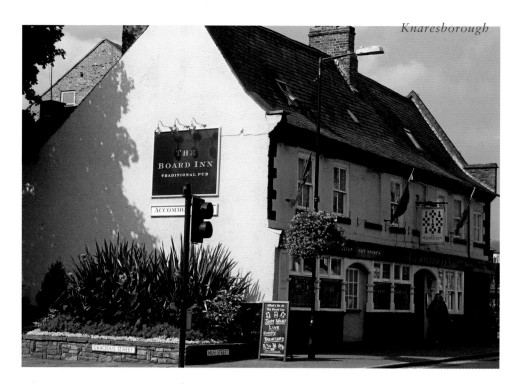

Knaresborough

The Board today.

Leeds United …

Vinyl heaven at The Board.

CASTLE VAULTS

23 Castlegate, Knaresborough HG5 8AR
01423 860 423

The pub celebrates nearby Knaresborough castle: Edward II's castle was all but destroyed by Oliver Cromwell's slighting in 1648 and was taken by the Parliamentarians in December 1644 after a siege. Not much remains other than the barbican gate, the keep and the dungeon.

We learn from *The Chronicle of John de Brompton* that the four knights who murdered Archbishop Thomas Becket in Canterbury Cathedral on 29 December 1170 took refuge in Knaresborough Castle; their leader, Hugh de Morville, was Constable of the Castle. *The Chronicle* adds that the castle dogs, displaying more morals than the murderers, declined to eat the scraps that the four assassins threw down from their table.

One of the best and most original buildings in Knaresborough, designed perhaps to recall the castle that the pub commemorates and castle locks and keys in The Castle, originally from the Cross Keys round the corner.

THE WORLD'S END

65 Bond End, Knaresborough HG5 9AU
01423 863 221

This pub on High Bridge dates from around 1898 when it replaced the original tavern. It was owned by Charles Blenkhorn, who also ran the nearby pleasure boats, hotel and café. He was also town postmaster with his sister postmistress. At one time the pub sign is said to have depicted an earthquake with a bus falling into a river.

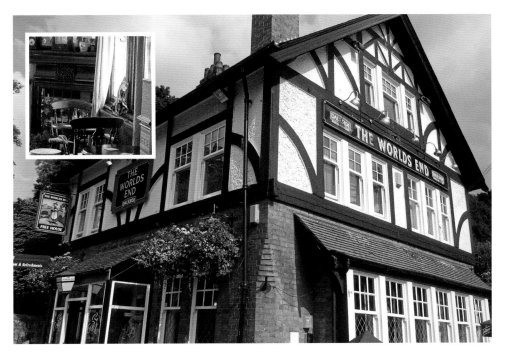

Above: The World's End today with Mother Shipton sign.

Inset: Witch at the World's End.

Inside the World's End.

The World's End as it was around 1898. The licensee, Charles Blenkhorn, also ran a pleasure boat business near High Bridge as the sign shows.

BLIND JACK'S

19 Market Place, Knaresborough HG5 8AL
01423 869 148
http://www.roosters.co.uk

Blind Jack is the nickname of John Metcalf, who was born in 1717 in a cottage (demolished in around 1768) near Knaresborough parish church and was a veritable jack of all trades. He attended school aged four, but at the age of six was struck by smallpox which left him completely blind.

An intelligent boy with prodigious determination and energy despite his disability, he led an active life climbing trees, swimming, hunting and gambling. At fifteen he was appointed fiddler at the Queen's Head in High Harrogate. Later, he earned money as a local guide (mainly by night), eloped with Dolly Benson, daughter of the landlord of the Royal Oak (later The Granby) and, in 1745, marched as a musician to Scotland, leading Captain Thornton's 'Yorkshire Blues' to fight Bonnie Prince Charlie's rebels. Blind Jack is best known for his work as a pioneer of English road building. His extensive travels, and the stagecoach he ran between York and Knaresborough, had made him all too familiar with the appalling state of English roads. Soon, after a new Turnpike Act in 1752, he procured a contract for building a three-mile stretch of road between Ferrensby and Minskip. Then he built part of the road from Knaresborough to Harrogate, including a bridge over the Star beck, and went on to lay around 180 miles of road in Yorkshire, Lancashire and Derbyshire. The specially

Blind Jack's in the Market Square.

constructed viameter he used to measure his roads can still be seen in the Knaresborough Courthouse Museum. Following Dolly's death in 1778, he went to live with his married daughter in Spofforth. Here, after many active years in business and as a violin player, he died in 1810, leaving behind four children, twenty grandchildren and ninety great- and great-great-grandchildren. A tombstone in Spofforth churchyard pays tribute to the remarkable achievements of 'Blind Jack of Knaresborough'. He was commemorated with a bronze statue by Barbara Asquith in Knaresborough marketplace in 2009.

THE DROPPING WELL INN

> Low Bridge, Knaresborough HG5 8HZ
> 01423 861 606

Also known as Mother Shipton's Inn, Mother Shipton herself features on the copper sign above the door in this 1914 photo. The Dropping Well estate was run by a Mrs Comer and her five daughters in the early twentieth century until they were forced to leave when the Slingsby family lost the Slingsby baby case concerning the legitimacy of their child and its right to the family's fortune in 1916. They lost their case, and in 1916 the Slingsby Estate, covering much of Knaresborough, was sold off by public auction; the Dropping Well Estate, for example, was bought by J. W. Simpson. The last direct male descendant in the Slingsby line, Sir Charles of Scriven Hall was a keen huntsman, and, unfortunately, is remembered as much for his tragic death during the York and Ainsty

The Dropping Well with its eighteenth-century copper sign showing Mother Shipton. This was the entrance to the Dropping Well estate. The pub was owned by the Slingsbys until they sold it in 1915.

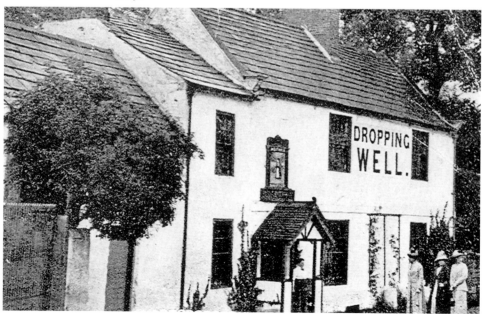

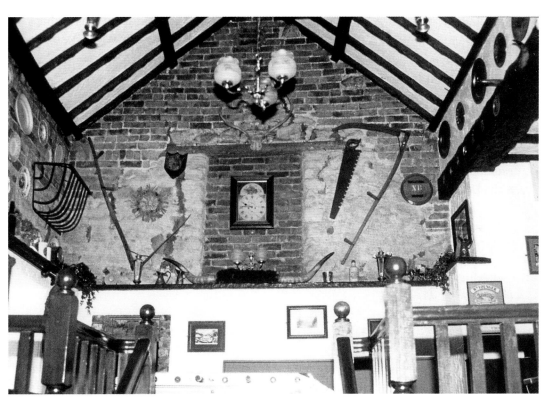

The old games room at the Dropping Well.

fox-hunt on 4 February 1869 as anything else. A fox was spotted at Monkton Whin and pursued for a full hour. When Slingsby crossed the River Ure near Newby Hall at Stainley House between Harrogate and Ripon in a flat-bottomed boat used for maintenance at the hall, the horses in the crowded ferry-boat became restless. Saltfish, Slingsby's horse, kicked the horse of Sir George Wombell. Saltfish leapt from the boat dragging Slingsby with him. The boat capsized and within minutes eight horses and six men, including Sir Charles, were drowned. Saltfish survived. The funeral at Knaresborough parish church was the largest in the town's history, with at least 1,500 mourners arriving on foot, as well as ten coaches of dignitaries and fifty-three private carriages.

Born in 1488 (so fifteen years before Nostradamus) in a cave next to the River Nidd, the legendary Mother Shipton (née Ursula Southeil) is synonymous with Knaresborough, and with the art of prophecy. Suffering from what was probably scoliosis, and variously branded a witch and the devil's daughter, her predictions included the downfall and demise of Cardinal Wolsey, the Gunpowder Plot, the Great Fire of London, her own death and the end of the world in 1881 and 1991. She did not appear in records until 1641 when, living in York, she predicted that the disgraced Cardinal Wolsey, who planned to be enthroned as Archbishop in 1530, would see York but never reach the city. Wolsey got as far as Cawood Castle, and from the tower saw York Minster in the distance, vowing he would have Mother Shipton burnt as a witch.

But he was arrested on a charge of high treason and died on the journey south. This first printed version of the prophecies spread the fame of Mother Shipton throughout England. In 1667, a fictionalised account of her by Richard Head says she had been born (after her mother had been seduced by the Devil in disguise) at Knaresborough, 'near the Dropping Well'. Head's publication contains the first of many fabricated prophecies attributed to Mother Shipton, all written after the events (e.g. the defeat of the Spanish Armada). Forgeries were taken a stage further by the Brighton bookseller Charles Hindley who in 1873 confessed that he had fabricated prophecies about modern inventions and the one that had caused much alarm: Then the world to an end shall come / In eighteen hundred and eighty one. Despite claims by numerous other towns, Knaresborough is where Mother Shipton was born – to Agatha during a violent thunderstorm.

The Dropping Well is one of Britain's oldest tourist attractions. This petrifying well derives its name from the water dripping over a limestone rock into a little pool before joining the Nidd. The earliest known description is by John Leland, the antiquary of Henry VIII. After his visit in around 1538, he wrote of 'a Welle of a wonderful nature, caullid Droping Welle. For out of the great rokkes by it distillith water continually into it … what thing so ever ys caste in and is touched of this water, growth ynto stone'. A tourist attraction since 1630, the Petrifying Well has intrigued visitors with its

The Dropping Well today, renamed the Mother Shipton.

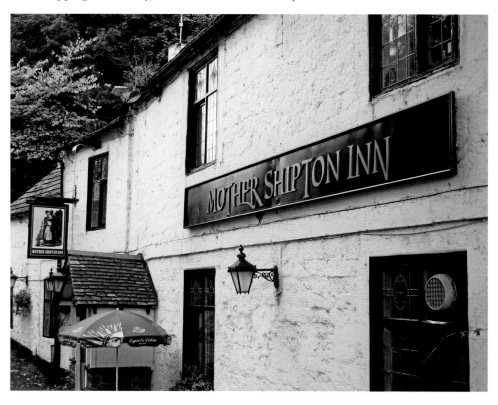

seemingly magical ability to change everyday objects into stone by depositing layers of calcite on them. Seven hundred gallons of water flow through every hour and it takes approximately six months to 'petrify' a teddy bear, for example. Today, the well features a highly imaginative array of articles, some of which are in the museum. Nowadays, the overhang is regularly scraped to prevent collapse, as happened in 1704, 1816 and 1823.

THE COMMERCIAL

70 High St, Knaresborough HG5 0EA
01423 862 170

The Borough Bailiff, the former name, was where the borough's bailiff lived in the seventeenth century; the exterior was refurbished in the eighteenth. The Borough Bailiff was the principal officer keeping law and order in the town, from medieval times until the nineteenth century when the police force took over. He was a kind of Justice of the Peace presiding over the Borough Court. Some Borough Bailiffs were wealthy and influential, including Peter Benson in Knaresborough who, by 1611, had sixteen burgage houses (with their voting rights), and in 1616 donated a house for the new grammar school. Appropriately, one of Peter Benson's houses was later known as the Borough Bailiff, which has served as an inn from around 1720, under the name the Commercial Hotel. Responsibility for an official fire brigade was taken over by the Improvement Commissioners in 1860 when the town surveyor was put in charge of the fire engine. This used to be kept behind the Borough Bailiff, where the bell used to summon the brigade can still be seen.

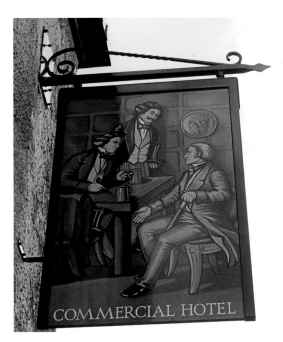

Business as usual at The Commercial or should that be the Borough Bailiff?

DOWER HOUSE

> Bond End, Knaresborough HG5 9AL
> 01423 863 302
> http://www.dowerhouse-hotel.co.uk/pages/about.php

The Dower House is situated in Bond End in that part of Knaresborough known as Tentergate. In the Middle Ages this was where the bondsmen or serfs of the town lived, hence the name Bond End. There are records in the Slingsby Archives relating to 1541, of a lease from 'Thomas Slingsby of Scriven to Richard Slater and Margaret his wife of Lylley Hall, barn and kiln in the area of Tentergate'. The Dower House has been known by several names, three of these being Lylley Hall in the 1500s, Bond End House between 1750 and 1910 and the Dower House, its current name from around 1911. Dower houses were typically large and used as the place of residence for widows of earls and dukes. The widow – known as the dowager – usually vacated the dower house and moved into a smaller property on the grounds of the estate. Then, the new heir would replace her in the main house. Famous royal dower houses include Clarence and Marlborough houses in London and Frogmore House at Windsor Castle.

ROOSTERS BREWERY LTD

> Wetherby Road, Knaresborough HG5 8LJ
> 01423 865 959
> http://www.roosters.co.uk/

One of the John Wayne-themed and branded beers available from Roosters.

Roosters started life in 1980 as Franklin's Brewery, based at the Gardener's Arms in Harrogate. Two years later Sean Franklin moved the company with a new name: Roosters. The name was inspired by John Wayne and his role as Rooster Cogburn in *True Grit*, leading to the launch of Yankee and other western-themed brands. Since 2011 it has been run by the Fozard family in Knaresborough.

Yankee (4.3%) is joined by Buckeye (3.5%), Wild Mule (3.9%), True Grit (also 3.9%), YPA or Yorkshire Pale Ale (4.1%), Fort Smith (5%), an IPA-style beer named after the town where *True Grit* was filmed, Cogburn (4.3%), All Star Yakima Pale Ale (4.3%) and Londinium (5.5%). Outlaw is a subsidiary company run for specialist and trial beers. Under Outlaw, the Fozards produce a coffee porter in conjunction with Betty and Taylor's of Harrogate. Bettys are also involved in a jasmine tea beer.

THE BAY HORSE INN

> Main St, Goldsborough, HG5 8NW
> 01423 862 212

The Bay Horse Inn is situated opposite the village cross in a building dating back to 1600. The original beams can still be seen and it boasts an unusual circular, iron chandelier. Over the open fireplace is the coat of arms of the Harewood family who previously owned the pub, and indeed the whole village. In 1958 the land, including the pub, was sold for £4,200. The pub was once a staging post, and before that there was a Roman settlement nearby.

The Bay Horse with war memorial.

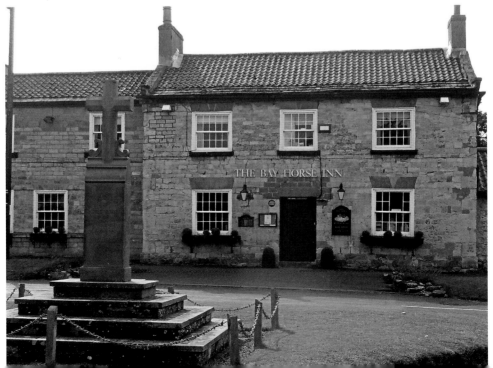

THE TIGER INN

> Coneythorpe, Nr Harrogate, HG5 0RY
> 01423 863 632
> http://www.tiger-inn.co.uk/about

Coneythorpe is in the parish of Goldsbrough and was originally called Kingsthorpe. The correct name of the village is Coneythorpe with Clareton, as given by the *Domesday Book*. You can still see the old village pump outside the Tiger Inn, now restored and once the village's only source of water.

The name Coneythorpe is derived from the old Danish *konig-thorpe* or *koning-thorpe* meaning king's settlement. Before 1066 the village was owned by Edward the Confessor and granted to William Mauleverer in gratitude for support to William I at the Battle of Hastings. The earliest record of Coneythorpe can be found in the Episcopal Registers of 1275; in older documents and maps Coneythorpe is sometimes referred to as Kingsthorpe. Until the late 1960s most of the houses in and much of the land around Coneythorpe and Clareton were still owned by the Allerton Mauleverer estate. The village was sold by auction in 1968. Adverts for the auction and newspaper cuttings regarding the sale can be seen in the Tiger Inn.

The Tiger Inn today.

THE ALICE HAWTHORN

The Green, Nun Monkton YO26 8EW
01423 330 303
enquiries@thealicehawthorn.com
http://www.thealicehawthorn.com/#!about-us/cee5

The Alice Hawthorn Inn has stood on Nun Monkton's pleasant green village for over 220 years. The Anglo-Saxon name for the village is Monechtone. The 18-acre green is one of England's largest and one of the last working greens in Yorkshire and in keeping with the name of the pub, livestock still graze there contentedly.

The venerable old pub is named after one of the greatest English race mares we have known. Born in 1838, Alice Hawthorn won fifty-one races (and ran one dead heat) out of seventy-one races and was placed in ten others in just five seasons including two victories at the Doncaster Derby and Queen's Vase Cup. There were fourteen other cups and eighteen Queen's plates. You can find paintings of this 'queen of the turf' around the pub. The pub was originally called the Blue Bell, after the landlord's mistress. There were at least three pubs in the village in the past: the White Horse was opposite on the other side of the green where White Horse House now stands.

There are numerous pubs named after famous racehorses: Yorkshire alone has more than thirty. To name but a few there is the Flying Dutchman in Summerbridge on the road from Knaresborough to Pateley Bridge – the sign here originally showed the ship of that name but was changed to depict the racehorse when it won the Derby and

An early photograph of the Alice Hawthorn.

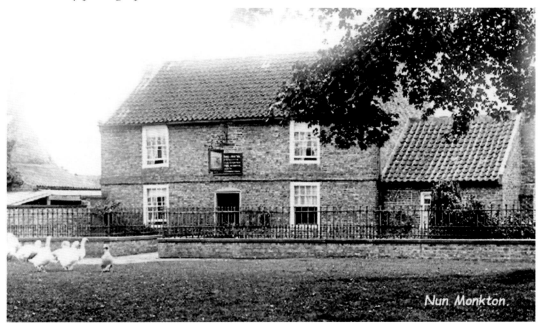

Nun Monkton.

The Alice today and (*inset*) an old turnstile used at York racecourse in one of the Alice Hawthorn outhouses.

St Leger in 1849; the Altisidora in Bishop Burton near Beverley commemorating the 1813 St Leger winner – before that the pub was named the Horse & Jockey; the Cleveland Bay at Redcar; the Little Wonder in Harrogate (now closed) named after a 50:1 Derby victor in 1840; it was the 'Little' Wonder because it only stood fifteen hands high and cost its owner a mere sixty-five guineas.

There is another Alice Hawthorn in Wheldrake near York, and the Brigadier Gerard in York itself. The Gas Works Social Club was an earlier use for this former school building which was extended and converted into the Brigadier Gerard in Monkgate in 1984. The name comes from the famous racehorse that won seventeen of its eighteen races – the sole defeat was at York in 1972. The horse in turn was named after Brigadier Etienne Gerard, the eponymous hero in Arthur Conan Doyle's *Exploits of Brigadier Gerard*, a series of short stories originally published in *The Strand* magazine between 1894 and 1903. The Three Legged Mare in York's Petergate has nothing to do with horses; this pub is named after a triangular industrial gallows which despatched three felons at once; one of which was in use at the Knavesmire in York until 1801 before it was removed in 1812. There is a replica of the 'wonkey donkey' in the beer garden of the pub. There is no future in riding the three-legged mare.

THE SUN INN

York Road, Long Marston YO26 7PG
01904 738 258

Undoubtedly the most famous visitor to this pub would have been Oliver Cromwell, around the time of the famous and decisive Civil War battle at Marston Moor in 1664. The pub itself is named after Edward VI, and has long been populated by ghosts which include Cromwell himself, lots of Royalist troops and Prince Rupert of the Rhine fleeing on horseback. This is very much in keeping with the general supernatural reputation of the area.

Closing Time

In April 2015 CAMRA announced the results of its survey to find the country's best 200 community pubs. CAMRA has been judging pubs for décor, value for money, customer service and, of course, the quality of beer. For Yorkshire the list includes Barnsley: Old No 7; Bradford: Jacob's Beer House; Doncaster: Corner Pin; Halifax: Three Pigeons; Harrogate: Harrogate Tap; Mirfield: Flower Pot; Huddersfield: Grove Inn; Beverley: Chequers Micropub; Keighley: Brown Cow; Leeds: Kirkstall Bridge Inn; Hawes: White Hart Country Inn; Rotherham: Beehive; Pickering: Sun Inn; Sheffield: Kelham Island Tavern; Castleford: Junction; York: Maltings. Now, asked G.K. Chesterton, 'Will someone take me to a pub?', Get up and go out, and save a pub, or two.